The Art of the

MOULIN ROUGE ® PARIS

More than **25** interactive
projects inspired by the artwork
of the world-famous venue

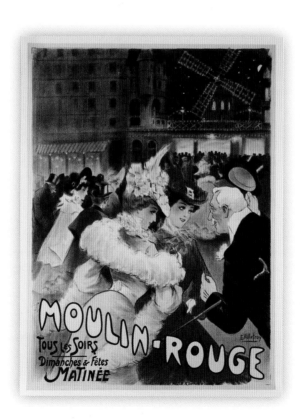

Quarto is the authority on a wide range of topics.
Quarto educates, entertains, and enriches the lives of our readers—
enthusiasts and lovers of hands-on living.
www.quartoknows.com

Published by Walter Foster Publishing,
an imprint of The Quarto Group
All rights reserved. Walter Foster is a registered trademark.

MOULIN ROUGE®
PARIS
82, boulevard de Clichy
75018 PARIS
www.moulinrouge.fr
www.moulinrougestore.com

6 Orchard Road, Suite 100
Lake Forest, CA 92630
quartoknows.com
Visit our blogs at quartoknows.com

Printed in China
1 3 5 7 9 10 8 6 4 2

MIX
Paper from
responsible sources
FSC® C101537

Table of Contents

The Stories of the Moulin Rouge 4

How to Use this Book 6

Tools & Materials 7

Other Media 8

Techniques. 10

How to Transfer a Template 12

Color-by-Number Key. 13

The Art of the Moulin Rouge 14

Practice Pages 33

Coloring Templates 37

Dot-to-Dot Templates 67

Color-by-Number Templates 85

Postcards . 97

The Stories of the Moulin Rouge

Moulin Rouge: The Parisian House of Celebrations

Through the ages, artists of all kinds—painters, singers, writers, fashion designers, costume designers, choreographers, film and stage directors, and others—have been inspired by the Moulin Rouge. Renowned artist Henri de Toulouse-Lautrec painted his muse there: the famous Cancan Dancer La Goulue, while the young designer Charles Gesmar dressed the famed Mistinguett with his extravagant costumes. Director Baz Luhrmann even took inspiration from the venue for his acclaimed 2001 film, *Moulin Rouge!*.

The stories of the Moulin Rouge began on October 6, 1889, during the Belle Époque period. Its creator, Joseph Oller, and manager, Charles Zidler, wanted to enable people from all walks of life to mix in the fashionable Paris district of Montmartre where artists, performers, and entertainers could socialize and live according to the values of pleasure and beauty. As Montmartre continued to grow in popularity, an innovative dance style known as the French Cancan also grew popular. Performed to an energetic rhythm by renowned

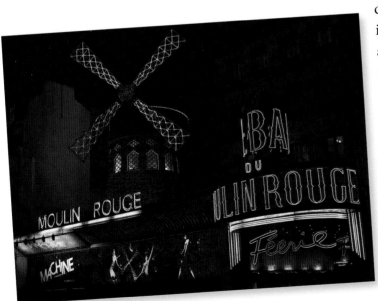

dancers, such as La Goulue, the image of the Cancan dancer appeared frequently in art, including on an emblematic poster for the Moulin Rouge painted by Toulouse-Lautrec. Wild, fast, brazen, and athletic, the French Cancan became the hallmark of the venue.

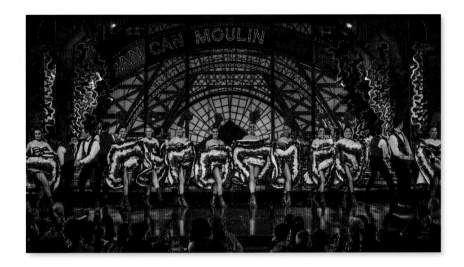

During the carefree 1920s, the talented Mistinguett, nicknamed the "Queen of the Music Hall," was at the pinnacle of her fame. A perfectionist, she managed every artistic aspect of the Moulin Rouge, including staging the revues and selecting costumes, sets, and music—all with a touch of modernity. Filled with feathers, silks, vivid colors, glitter, rhinestones, and lights, the revues of the Roaring Twenties were sumptuous and spectacular. In 1924, Mistinguett engaged the services of the young Charles Gesmar (1900-1928) to design her costumes, stage sets, jewels, and posters. A talented artist and designer, a great deal of Mistinguett's success and international celebrity is credited to Gesmar's work.

As stage to countless artists, in addition to a cabaret and music hall, the Moulin Rouge has transcended time as it has continuously reinvented itself as a venue merging tradition with technological innovation—always with the purpose of gifting intense moments of laughter and celebration. Today, the Moulin Rouge's eighty performers present *Féerie:* a colorful revue that treats spectators to a unique experience in an emblematic venue.

When the theater lights go down and the curtain opens, dancers take the stage in a spectacular performance filled with original French music and bursting with feathers, crystals, and sequins, against dazzling scenery. Through four lively and poetic scenes, the Moulin Rouge takes its audience on a journey through space and time. From the Garden of the Moulin Rouge in 1889 and the wild regions of Indonesia to a joyful and colorful circus and a nostalgic portrait of Paris through the ages, *Féerie* is full of surprises. Symbolized by the world-famous French Cancan—the most iconic dance of the Moulin Rouge—this revue is a tribute to the Parisian spirit of celebration.

How to Use This Book

Filled with coloring pages, dot-to-dot puzzles, and color-by-number templates based on the venue's most famous artwork, *The Art of the Moulin Rouge* invites coloring enthusiasts to add their own artistic flair to these legendary and symbolic works of Post-Impressionism. Following a brief introduction to different color mediums, artists will embark on a creative journey through time to celebrate the lifestyles that epitomize Parisian culture as seen through the portals of the storied Moulin Rouge.

- **Practice Pages** Two blank pages to use as you please—practice techniques, experiment with color, or create original art!

- **Coloring** Fifteen line-art templates to color with crayon, colored pencil, or marker— the choice is yours!

- **Dot-to-Dot** Nine dot-to-dot activity pages to complete and color.

- **Color-by-Number** Seven color-by-number templates. Use the number key on page 13 to complete the projects so they match the examples in the book, or choose your own colors to develop a unique piece of art.

Color directly inside the book, tear out the pages, or transfer the templates onto your own surface for endless coloring fun (see "How to Transfer a Template" on page 12)!

An artwork gallery helps you match your color to the originals, while 30 full-color, pull-out Moulin Rouge postcards are also included to display or share!

Tools & Materials

Before you begin coloring, get to know the range of tools available. Each medium has a unique feel and appearance, so choose the tools that best suit your style or mood.

Colored Pencils

Colored pencils are wood-encased leads made up of pigment and wax. Like traditional graphite pencils, you can sharpen them to points that can create fine lines and (if used at an angle) broad strokes. They give you a good amount of control over your strokes; the harder you press, the darker the line. You can also use an eraser to tidy up your lines.

Crayons

Crayons are a playful, inexpensive way to color your drawings. These wax-based tools have a soft feel and provide quick, textured coverage. Because they wear down quickly, crayons do not have sharp points for coloring in small areas.

Markers

Through tips made up of fibers, markers deliver ink from a reservoir onto paper. The marks are bold, crisp, and rich in color. Markers generally come in three types of tips: chiseled (wide and firm), fine (small and firm), and brush (soft and tapered).

Additional Materials

Other tools you may want to have on hand include:
- A drawing board to support your paper as you color
- A vinyl or plastic eraser (for colored pencils)
- An electric or hand-held sharpener (for colored pencils)
- A soft brush for removing dust and eraser crumbs (for colored pencils)

Other Media

Colored pencils, crayons, and markers may be the most convenient coloring media, but you're certainly not limited to them—especially if you're after soft blends or expressive, painterly effects. If desired, you can try soft pastel, oil pastel, watercolor paint, gouache paint, or acrylic paint. Note that if you plan to work with paint, you'll want to transfer the template to an appropriate support (such as watercolor paper or canvas). See page 12 for more on transferring.

Soft Pastel These chalk-like tools yield textured strokes and smooth blends. They are available in both stick and pencil form. These work best on textured drawing paper.

Oil Pastel Similar to crayons, these oil-based sticks produce thick, lively strokes. These work best on textured drawing or watercolor paper.

Colored pencils and markers are available individually and in sets at your local art-supply store. Always purchase the best quality you can afford, as high-quality tools yield better results. Student-grade materials (in contrast to artist-grade materials) contain a higher filler-to-pigment ratio, which affects the feel of the tools and vibrancy of the colors.

Watercolor This water-based paint is great for creating soft, translucent washes of color. To use this fluid medium, transfer your template to a sheet of watercolor paper.

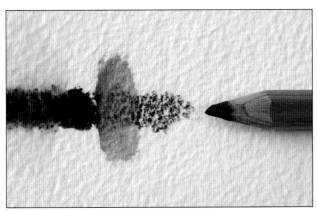

Watercolor Pencil Similar to colored pencils, you can use these to fill in the polygons of your templates. Then stroke a wet brush over to transform your strokes into wet washes of color. This medium also works best on watercolor paper.

Acrylic You can apply this water-based paint thinly (similar to watercolor) or thickly (similar to oil). Acrylic works best on canvas or watercolor paper.

Brushes When working in watercolor, you can use either natural or synthetic soft-haired brushes. When working in acrylic, synthetic bristles are best. Always rinse your brushes with warm, soapy water after use, and reshape the bristles to dry.

Techniques

Colored Pencil

Colored pencil works well on many surfaces, and a set of 24 wax-based colored pencils offers a good variety of color for beginners, covering the spectrum of color plus white, black, gray, and brown.

Varying Strokes Experiment with the tip of your pencil as you create a variety of marks, from tapering strokes to circular scribbles.

Gradating To create a gradation with one color, stroke side to side with heavy pressure and lighten the pressure as you move away, exposing more of the white paper beneath the color.

Layering You can optically mix colored pencils by layering them lightly on paper. In this example, observe how layering yellow over blue creates green.

Blending To blend one color into the next, lighten the pressure of your pencil and overlap the strokes where the colors meet.

Hatching & Crosshatching Add shading and texture to your work with hatching (parallel lines) and crosshatching (layers of parallel lines applied at varying angles).

Stippling Apply small dots of color to create texture or shading. The closer together the dots, the darker the stippling will "read" to the eye.

Burnishing For a smooth, shiny effect, burnish by stroking over a layer with a colorless blender, a white colored pencil (to lighten), or another color (to shift the hue) using heavy pressure.

Scumbling Create this effect by scribbling your pencil over the surface of the paper in a random manner, creating an organic mass of color.

Crayon & Pastel

Soft pastel has a chalky feel that can yield soft blends. Be sure to work on paper that has a textured surface so the raised areas catch and hold the pastel.

Unblended Strokes To transition from one color to another, allow your strokes to overlap where they meet. Leaving them unblended creates a raw, energetic feel and maintains the rhythm of your strokes.

Blending To create soft blends between colors, begin by overlapping strokes where two colors meet. Then pass over the area several times with a tissue, chamois, or stump to create soft blends.

Scumbling This technique involves scribbling to create a mottled texture with curved lines. Scumble over blended pastel for extra depth.

Stroking over Blends You can create rich colors and interesting contrasts of texture by stroking over areas of blended pastel.

Gradating A gradation is a smooth transition of one tone into another. To create a gradation using one pastel, begin stroking with heavy pressure and lessen your pressure as you move away from the initial strokes. Above is white gradated over a blue textured paper, lightly blended with a tissue.

Marker

Begin by choosing your color palette (or selection of colors). This will help you stick to dynamic color combinations while helping you avoid the chaos of too many color options.

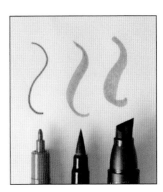

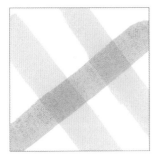

Mixing To mix markers, apply one color over another. They will blend in a way similar to paint; for example, blue over yellow creates green.

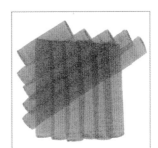

Layering The more you layer your strokes, the darker the color will appear. However, too many layers can wet the paper and cause it to tear.

How to Transfer a Template

Use your art templates again and again by transferring them to other surfaces using tracing paper or graphite paper.

Step 1 Trace the template onto a sheet of tracing paper, or make a photocopy of the template onto a sheet of copy paper, scaling it to your desired size.

Step 2 Coat the back of the paper with a layer of graphite using a pencil, or use a sheet of graphite transfer paper.

Step 3 Now place the template graphite-side down over your art paper or canvas. Using a pencil, ballpoint pen, or stylus, trace the template lines.

Step 4 Occasionally peel back the template to make sure the lines are transferring well to your drawing surface. The result will be a light guideline for creating your sketch!

Step 5 If desired, use a ruler and a fine-tipped permanent marker to trace the transferred lines.

Step 6 The result is a fresh template ready for color!

Color-by-Number Key

Use this color key to complete the color-by-number projects starting on page 85.

1	Medium blue	**11**	Peach
2	Dark blue	**12**	Lavender
3	Teal	**13**	Magenta
4	Grass green	**14**	Light red
5	Light olive green	**15**	Maroon
6	Olive green	**16**	Red
7	Forest green	**17**	Red-orange
8	Black	**18**	Yellow
9	Brown	**19**	Blue-gray
10	Beige	**20**	Light blue

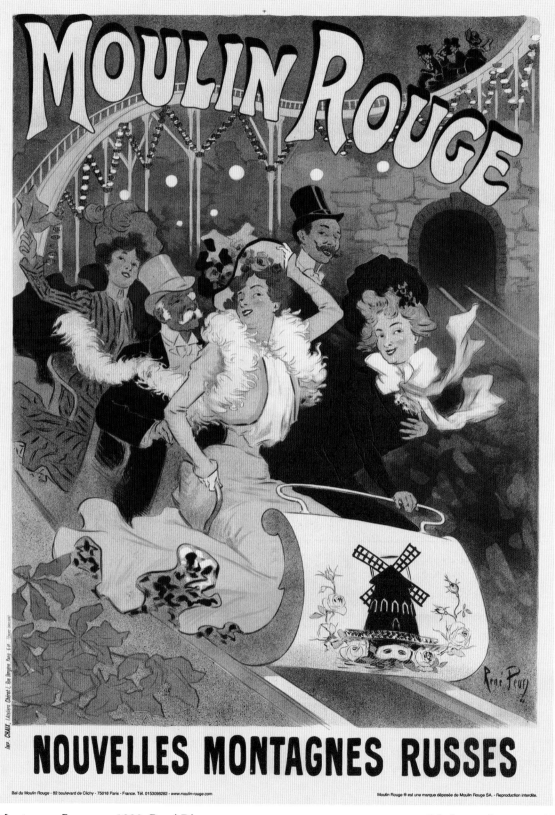

Montagnes Russes, c. 1889. René Péan.

Coloring template on page 37

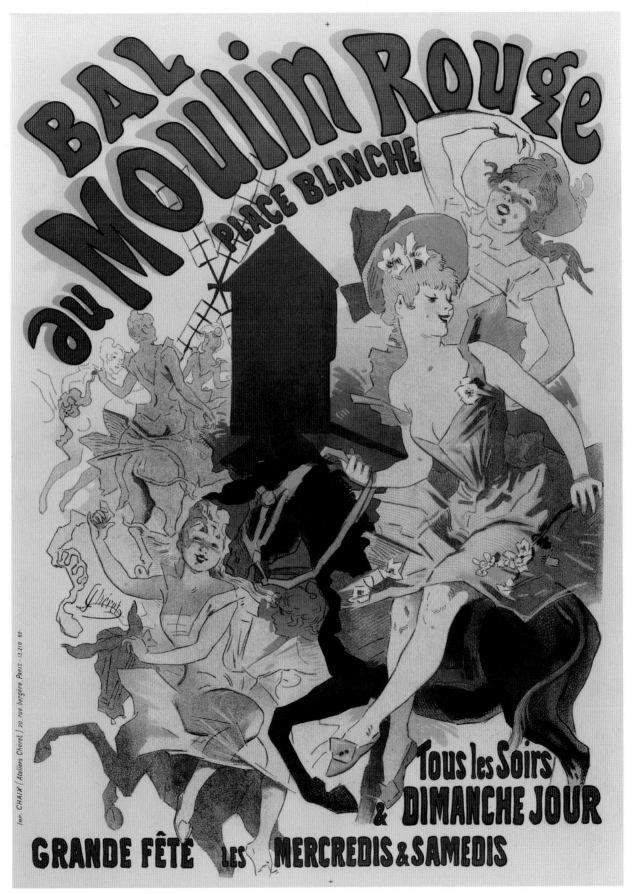

Bal du Moulin Rouge, c. 1889. Jules Chéret.

Coloring template on page 39

Coloring template on page 41

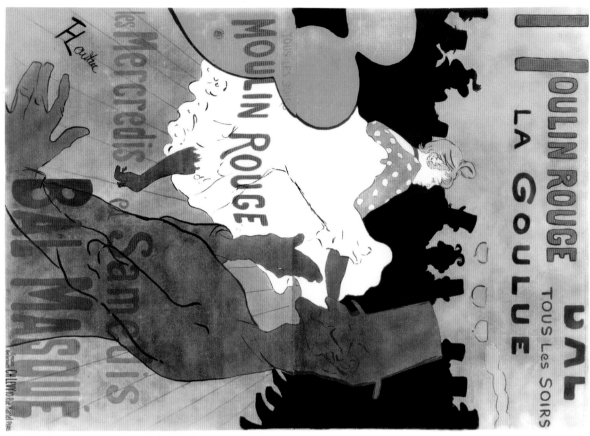

La Goulue, c. 1891. Henri de Toulouse-Lautrec.

Coloring template on page 43

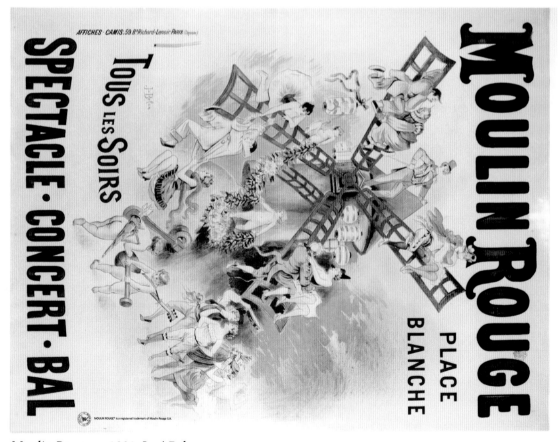

Moulin Rouge, c. 1891. José Belon.

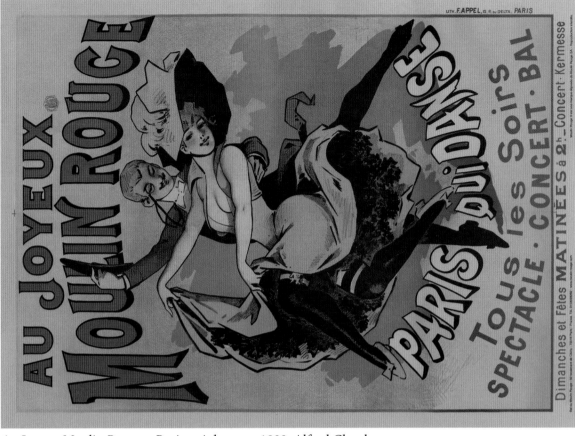

Coloring template on page 47

Au Joyeux Moulin Rouge – Paris qui danse, c. 1900. Alfred Choubrac.

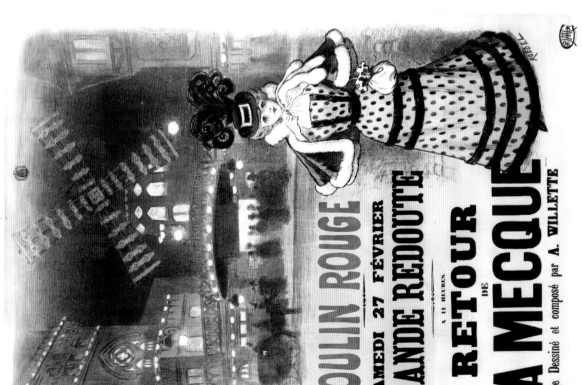

Coloring template on page 45

Grande Redoute, c. 1897. Auguste Roedel.

Coloring template on page 49

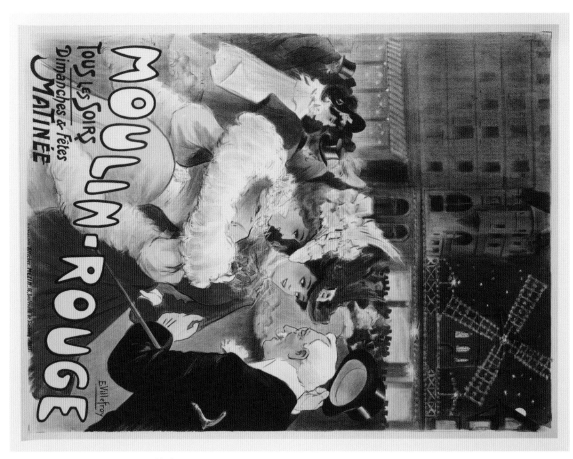

Moulin Rouge, c. 1900. Villefroy.

Coloring template on page 51

Tu Marches?, c. 1903. Jules-Alexandre Grün.

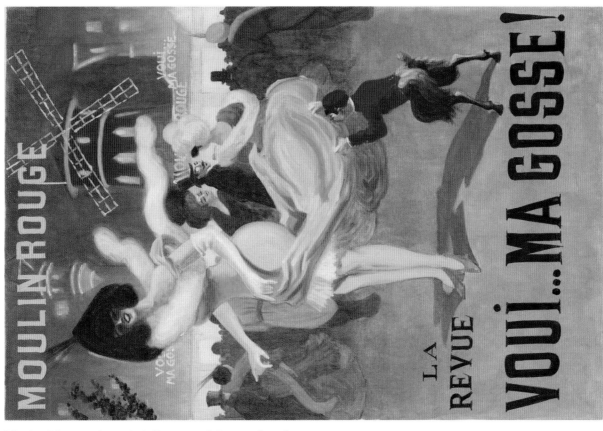

Coloring template on page 55

Voui… Ma gosse!, c. 1913. Rouvray & Lemarchand.

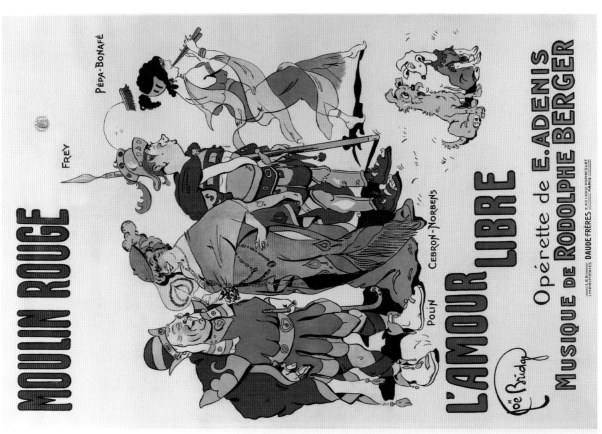

Coloring template on page 53

L'amour Libre, c. 1911. Joe Bridge.

Coloring template on page 57

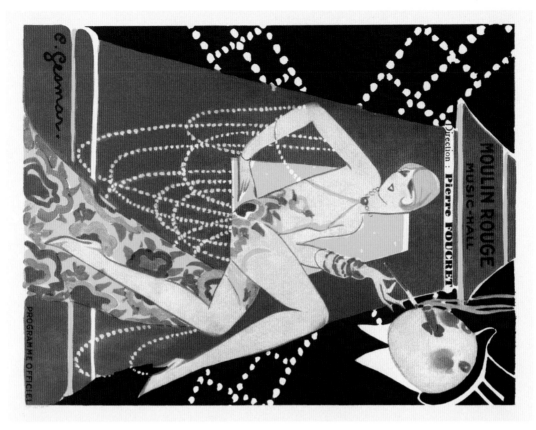

Ça, c'est Paris!, c. 1920s. Charles Gesmar.

Coloring template on page 59

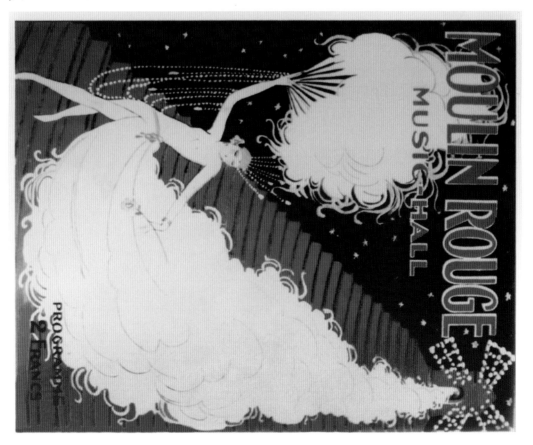

Mieux que nue, c. 1920s. Charles Gesmar.

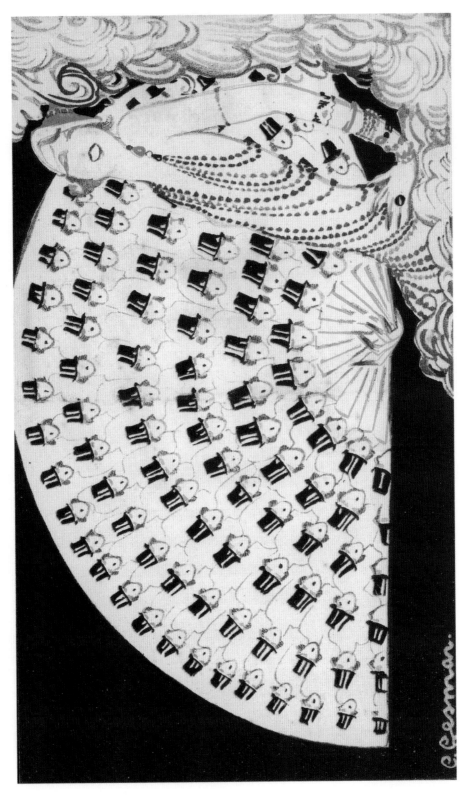

Coloring template on page 61

Ça, c'est Paris!, c. 1920s. Charles Gesmar.

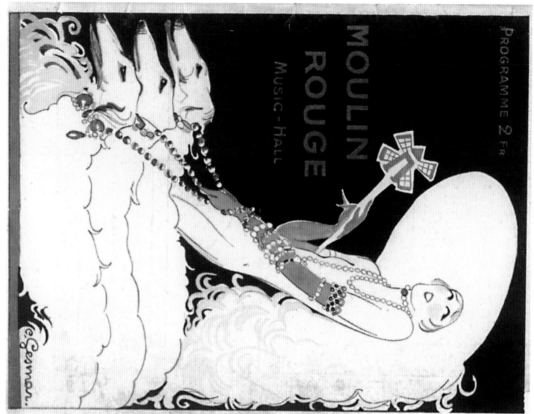

Coloring template on page 63

Paris qui tourne, c. 1920s. Charles Gesmar.

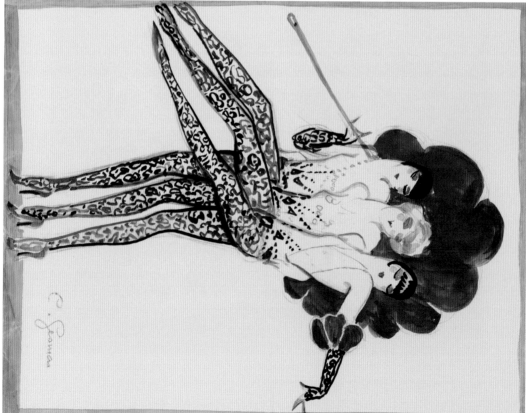

Coloring template on page 65

Moulin Rouge Costume Sketch "Triplettes," c. 1920s. Charles Gesmar.

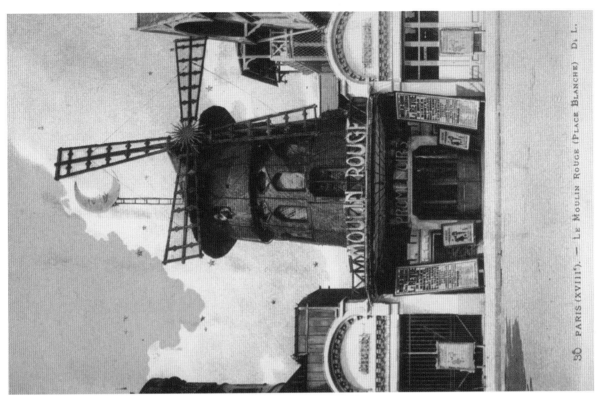

Moulin Rouge postcard, c. 1900. Villefroy.

Dot-to-dot template on page 69

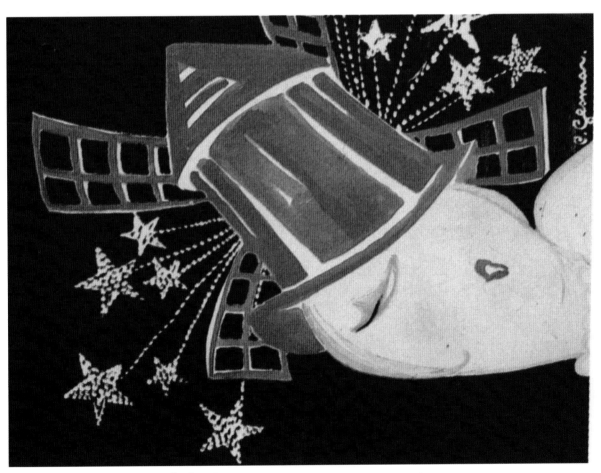

Paris aux Etoiles, c. 1920s. Charles Gesmar.

Dot-to-dot template on page 67

Dot-to-dot template on page 71

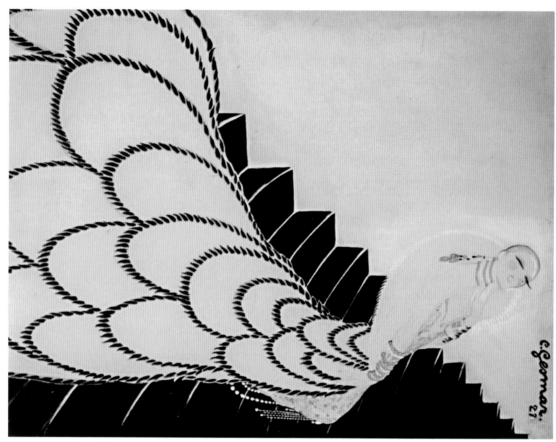

Moulin Rouge Costume Sketch, c. 1920s. Charles Gesmar.

Dot-to-dot template on page 73

Moulin Rouge Costume Sketch, c. 1920s. Charles Gesmar.

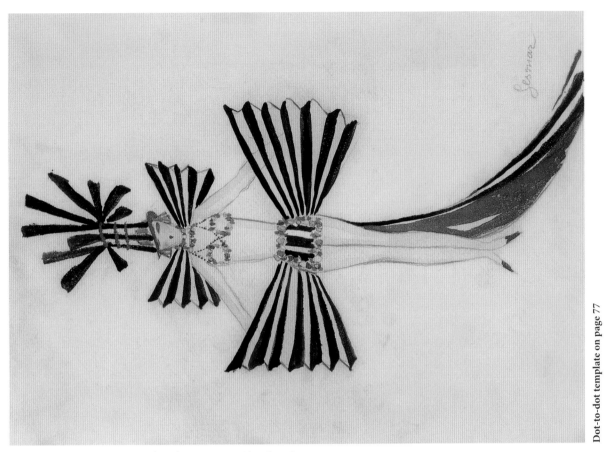

Moulin Rouge Costume Sketch, c. 1920s. Charles Gesmar.

Dot-to-dot template on page 77

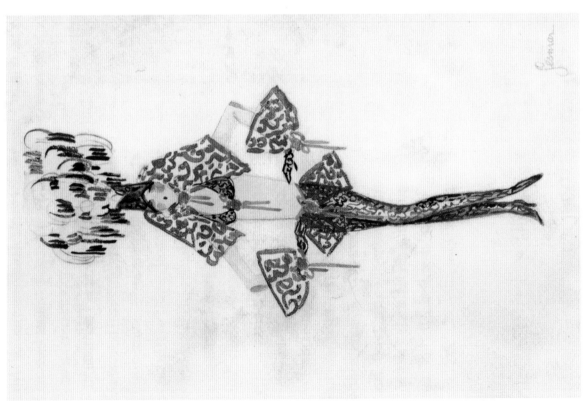

Moulin Rouge Costume Sketch, c. 1920s. Charles Gesmar.

Dot-to-dot template on page 75

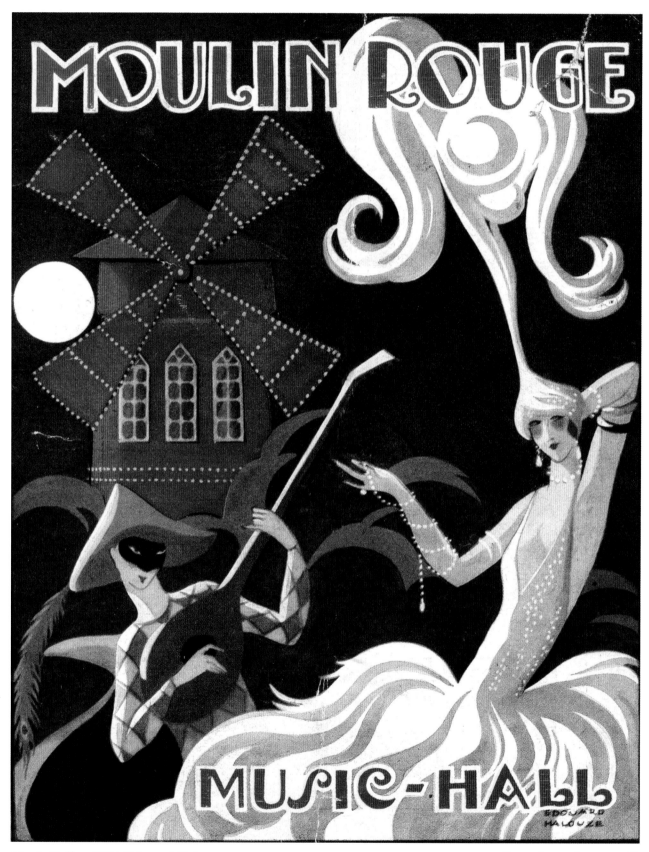

Music Hall, c. 1924. Edouard Halouze.

Dot-to-dot template on page 79

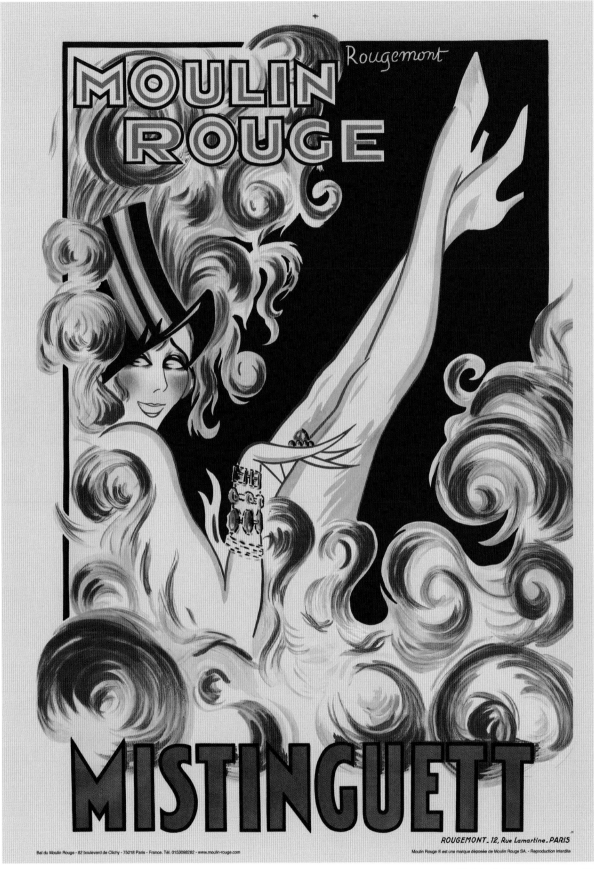

Mistinguett, c. 1928. Rougemont.

Dot-to-dot template on page 81

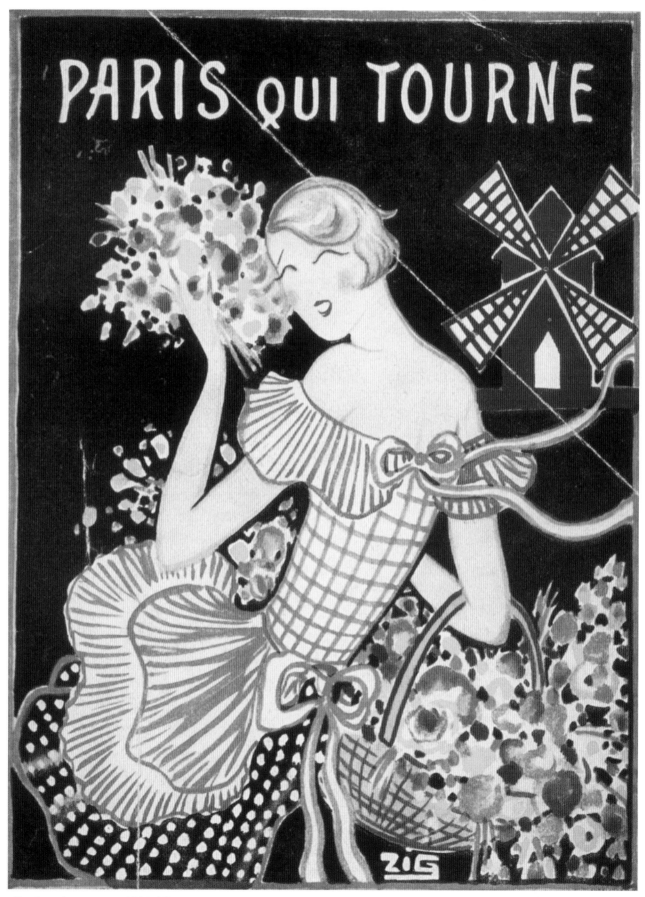

Paris qui tourne, c. 1929. Zig.

Dot-to-dot template on page 83

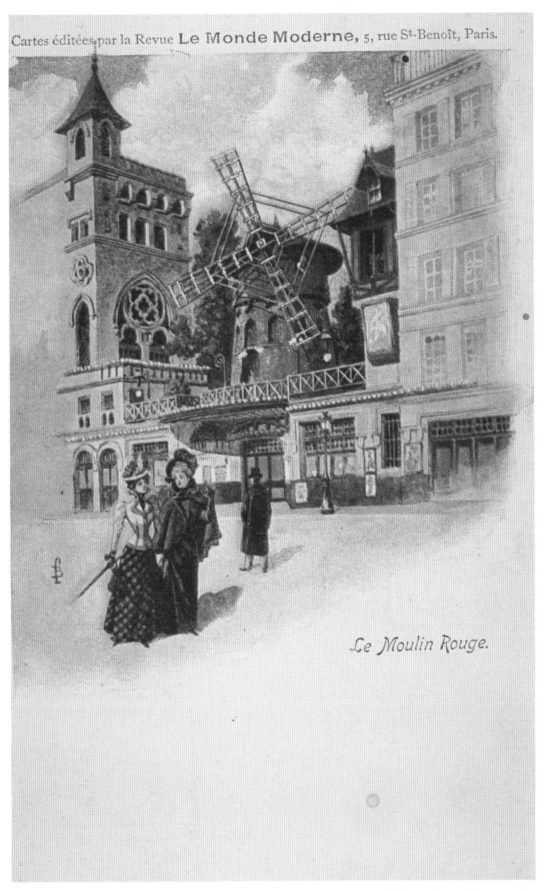

Cartes éditées par la Revue **Le Monde Moderne**, 5, rue St-Benoît, Paris.

Le Moulin Rouge.

Moulin Rouge postcard, c. 1905. Artist unknown. **Color-by-number template on page 85**

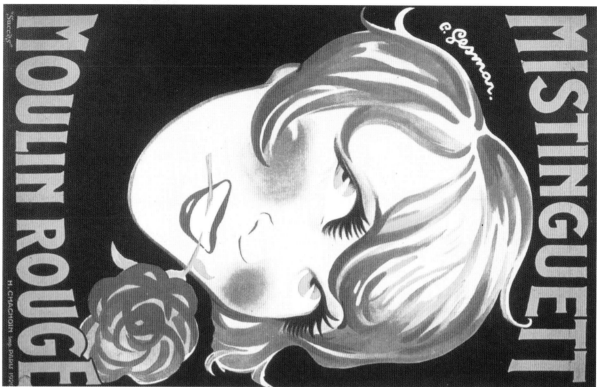

Color-by-number template on page 87

Mistinguett, c.1926. Charles Gesmar.

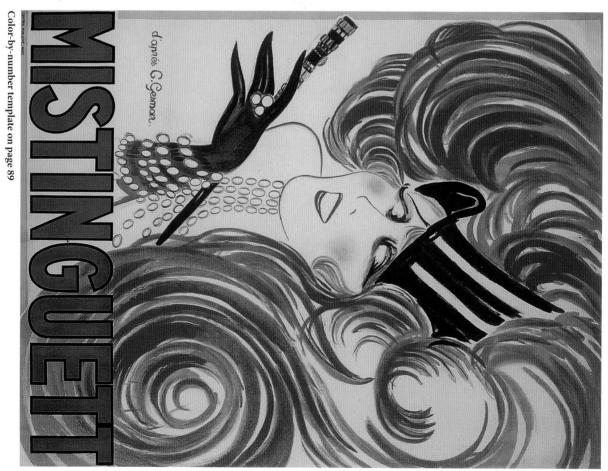

Color-by-number template on page 89

Mistinguett, c.1928. Charles Gesmar.

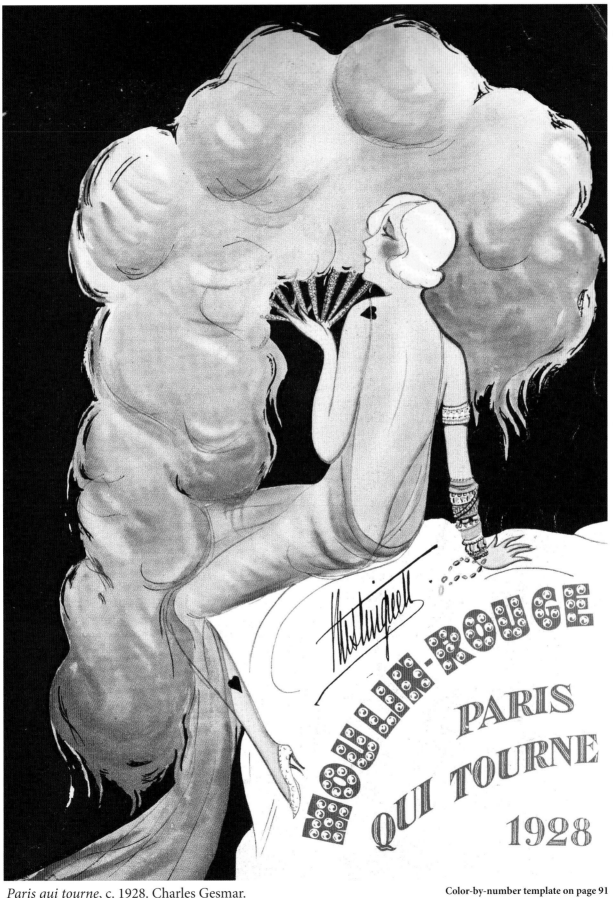

Paris qui tourne, c. 1928. Charles Gesmar.

Color-by-number template on page 91

Color-by-number template on page 93

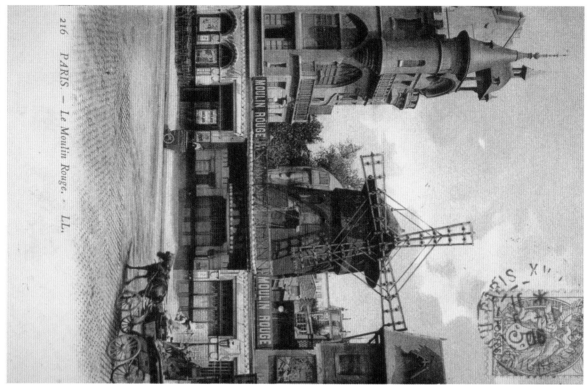

Moulin Rouge postcard, c. 1906. Artist unknown.

Color-by-number template on page 95

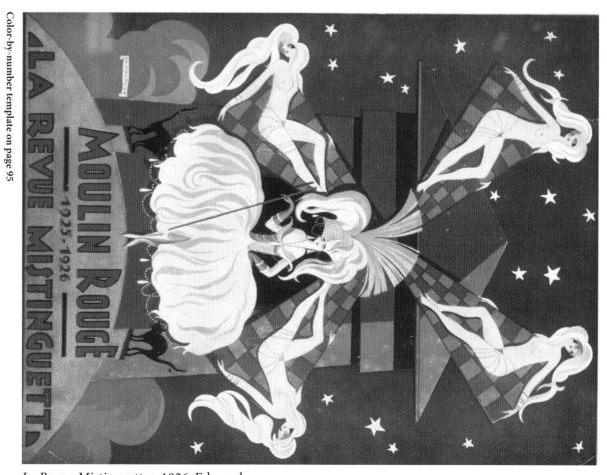

Le Revue Mistinguett, c. 1926. Edouard

Practice Pages

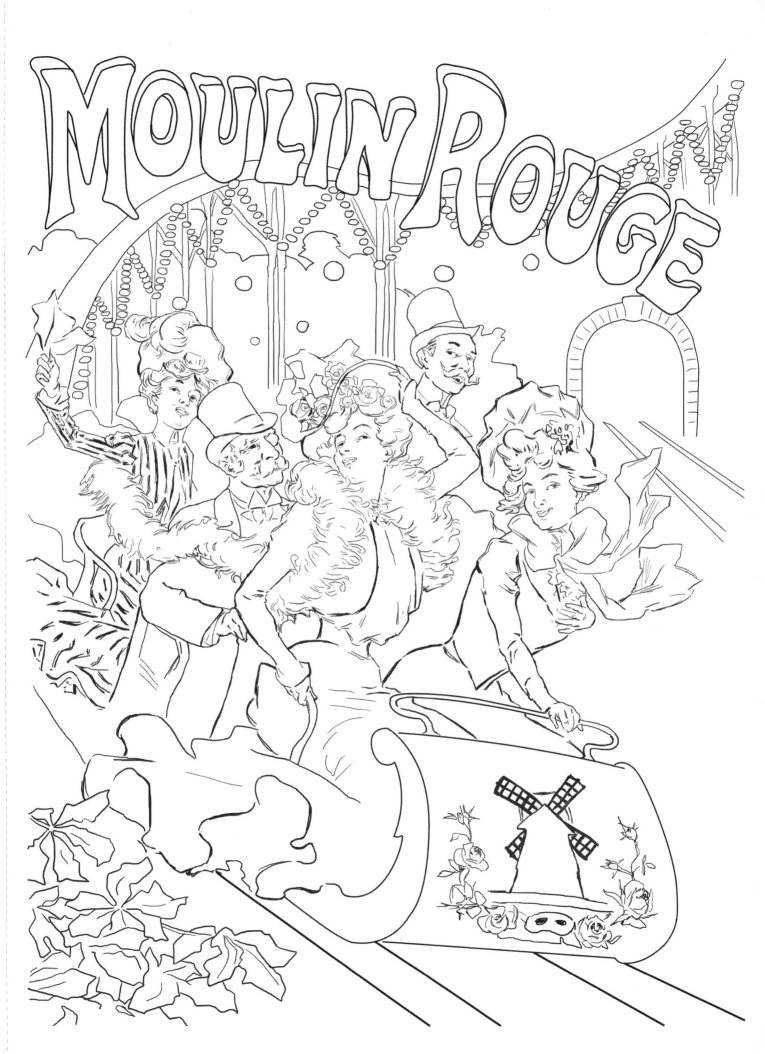

Montagnes Russes
c. 1889
René Péan
The Moulin Rouge has always been at the forefront of fun and entertainment. It is therefore natural that modern roller coasters were part of the numerous experiences to be had during the Belle Époque period!

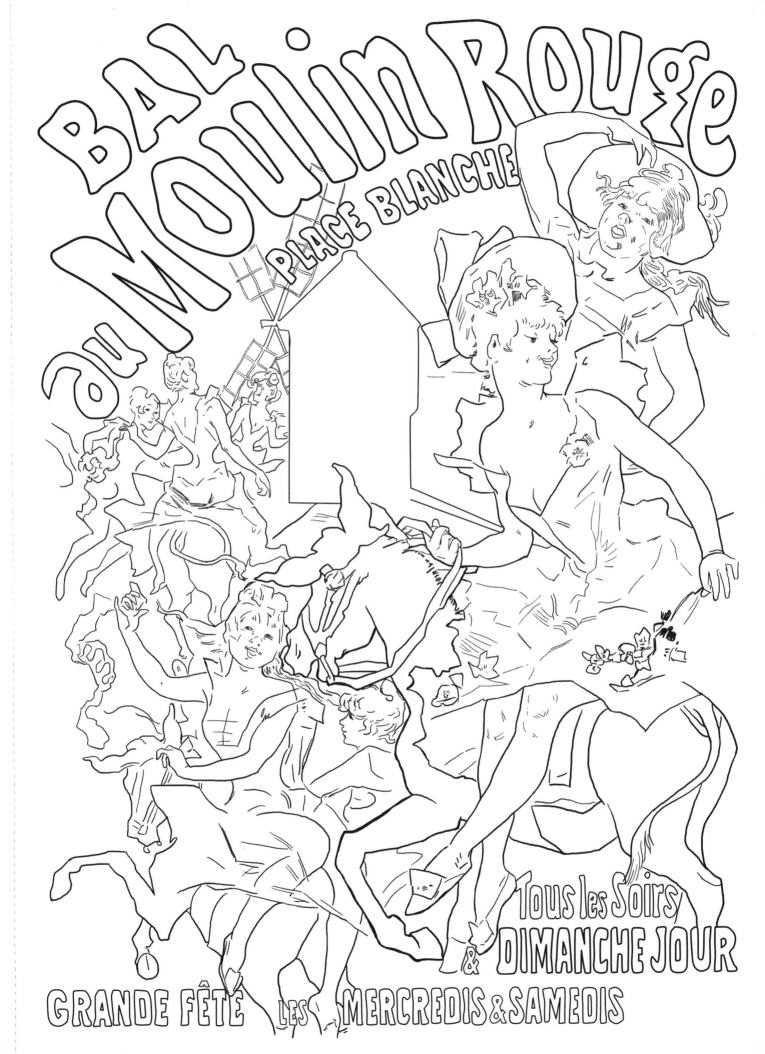

Bal du Moulin Rouge
c. 1889
Jules Chéret
The appearance of ponies in Montmartre introduced a bucolic atmosphere to the Moulin Rouge,
creating even more excitement for the artists of the time.

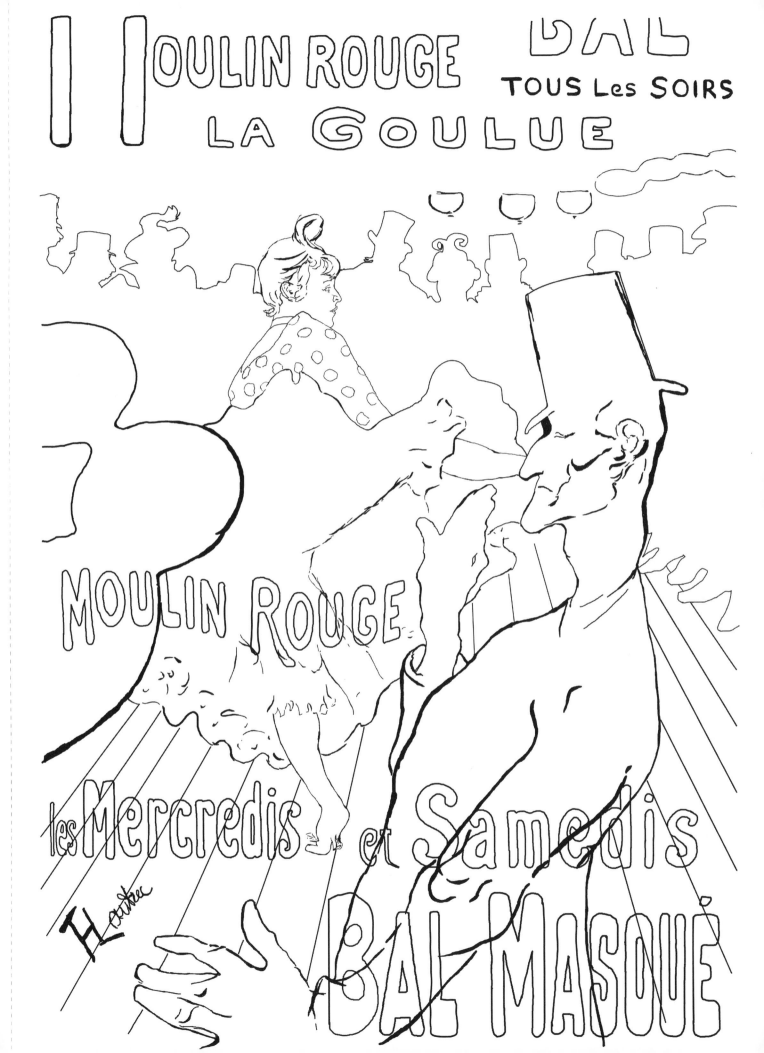

La Goulue
c. 1891
Henri de Toulouse-Lautrec
It was love at first sight between the brilliant Henri de Toulouse-Lautrec and the Moulin Rouge!
The famous painter quickly became the official illustrator of the Moulin Rouge with his poster displaying the
famous dancers La Goulue and Valentin Le Désossé.

Moulin Rouge
c. 1891
José Belon
The Moulin Rouge in all its glory! On stage, there are ongoing changes of scenery between the various performances of dancers, ventriloquists, acrobats, and other artists.

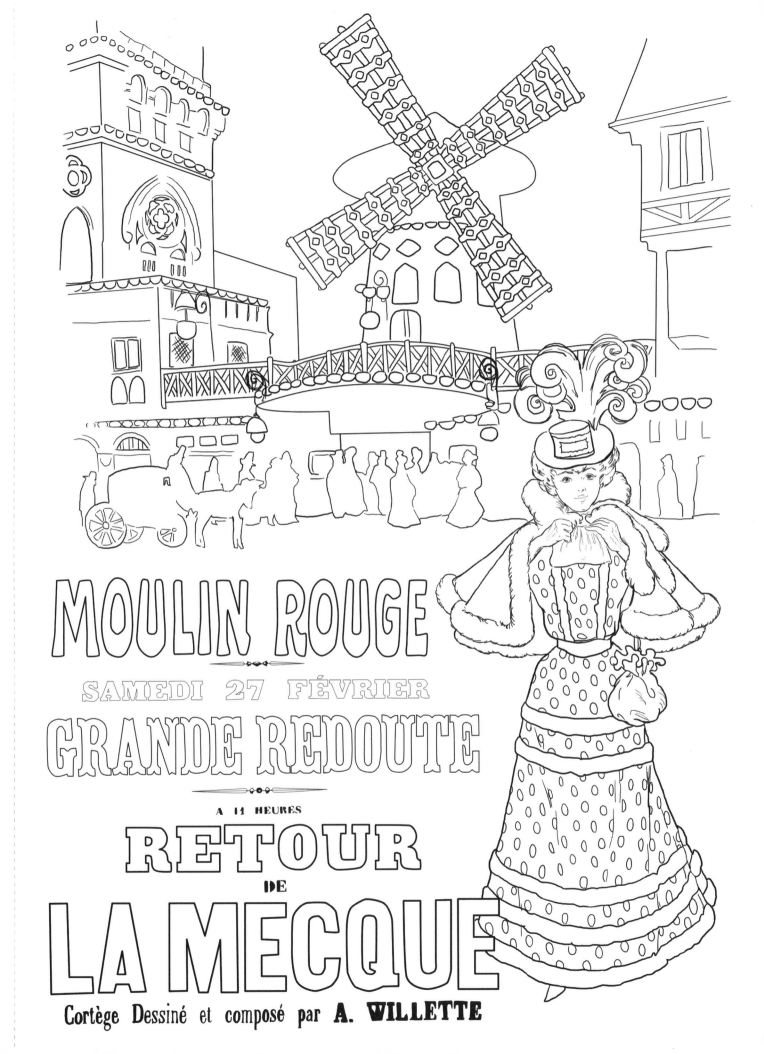

Grande Redoute

c. 1897

Auguste Roedel

The most elegant personalities in the world were present at the Moulin Rouge. The most beautiful women in Parisian squares rushed to the show to spend the evening under the sign of entertainment and celebration!

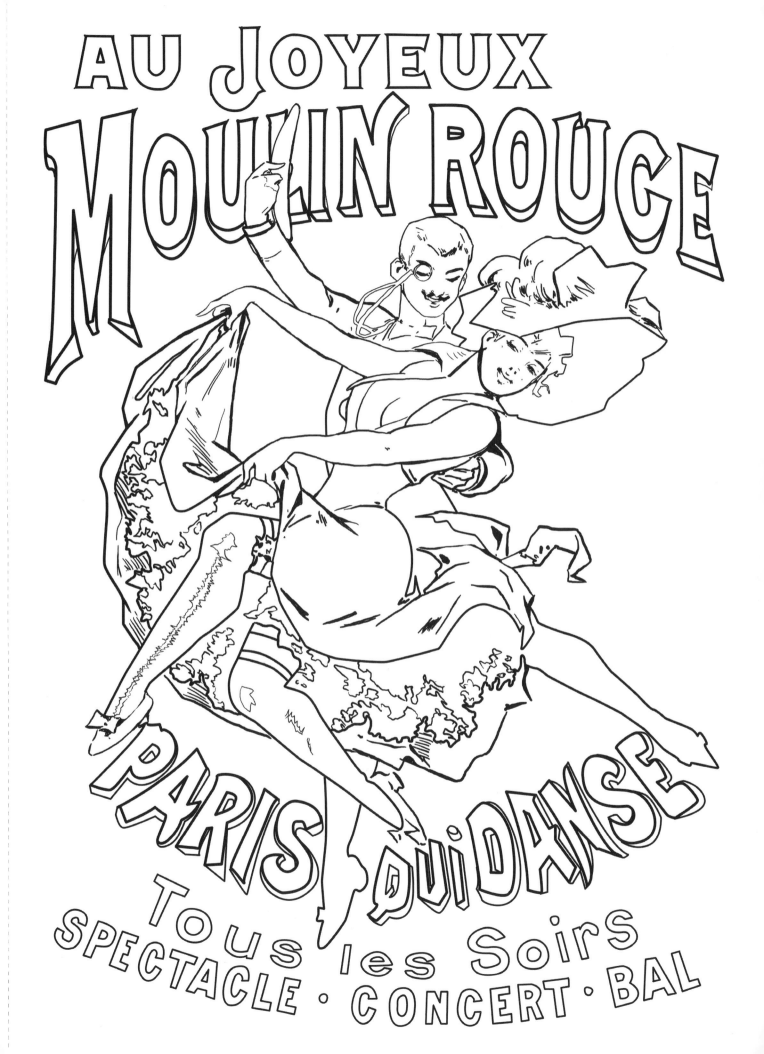

Au Joyeux Moulin Rouge – Paris qui danse
c. 1900
Alfred Choubrac
The Moulin Rouge has always offered an open invitation to dance and celebrate. It also means taking part in a dazzling universe where guests can meet each other and share a pure moment of joy and excitement.

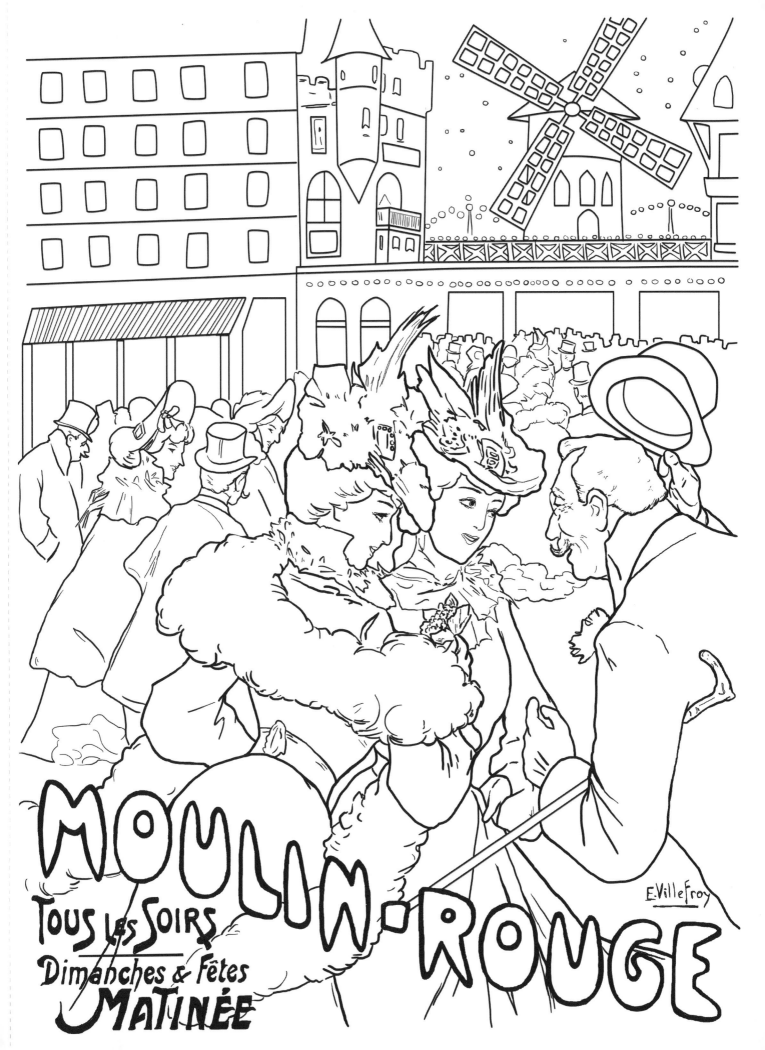

Moulin Rouge
c. 1900
Villefroy
Since its opening in 1889, some of the world's greatest artists and influencers have rushed to attend shows at the Moulin Rouge. Both the magic and extravaganza of this mythic place have made the Moulin Rouge the most famous dinner-and-show venue in the world!

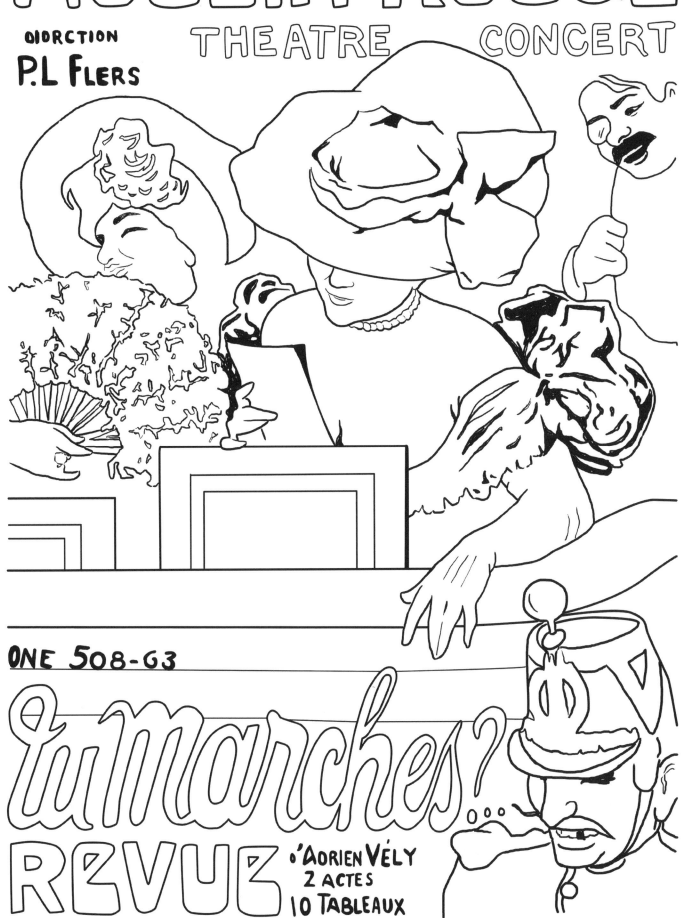

Tu marches?
c. 1903
Jules-Alexandre Grün

The Moulin Rouge has always been a women's palace where the most beautiful ladies of Montmartre went to be seen and admired. They exhibited sumptuous diamond and crystal jewels, as well as other precious stones set in the most fashionable accessories to ignite the admiration of others.

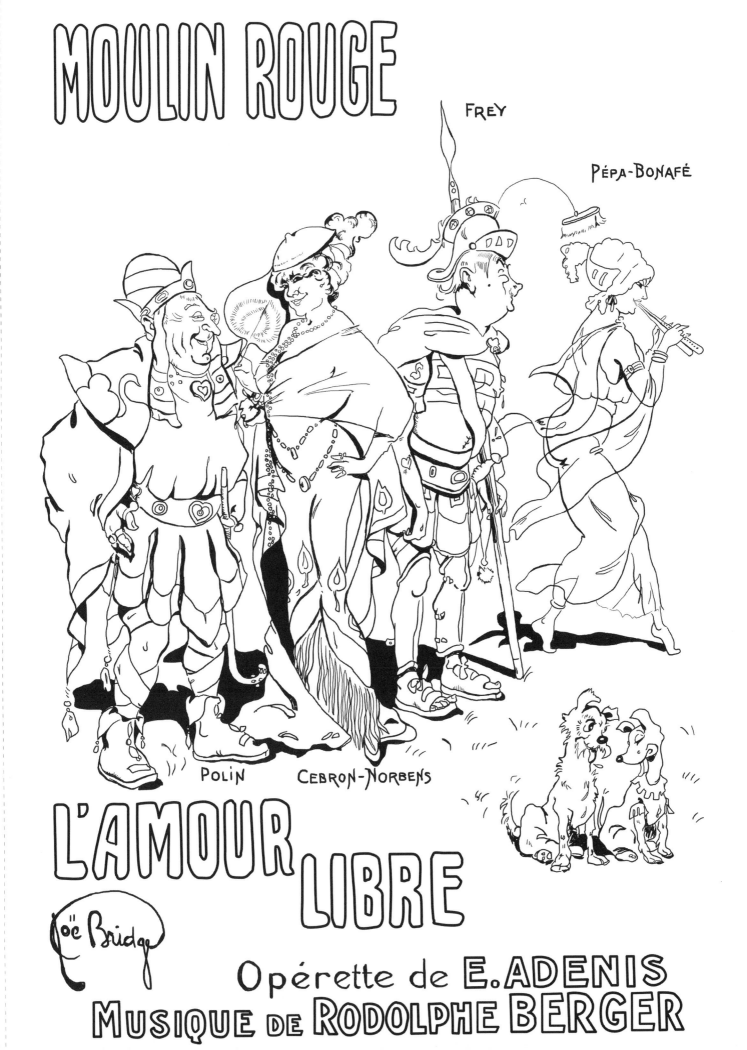

L'amour Libre
c. 1911
Joe Bridge
Thanks to quality shows and a bit of frivolity, women from every social background claimed their freedom to demonstrate extravagance and originality.

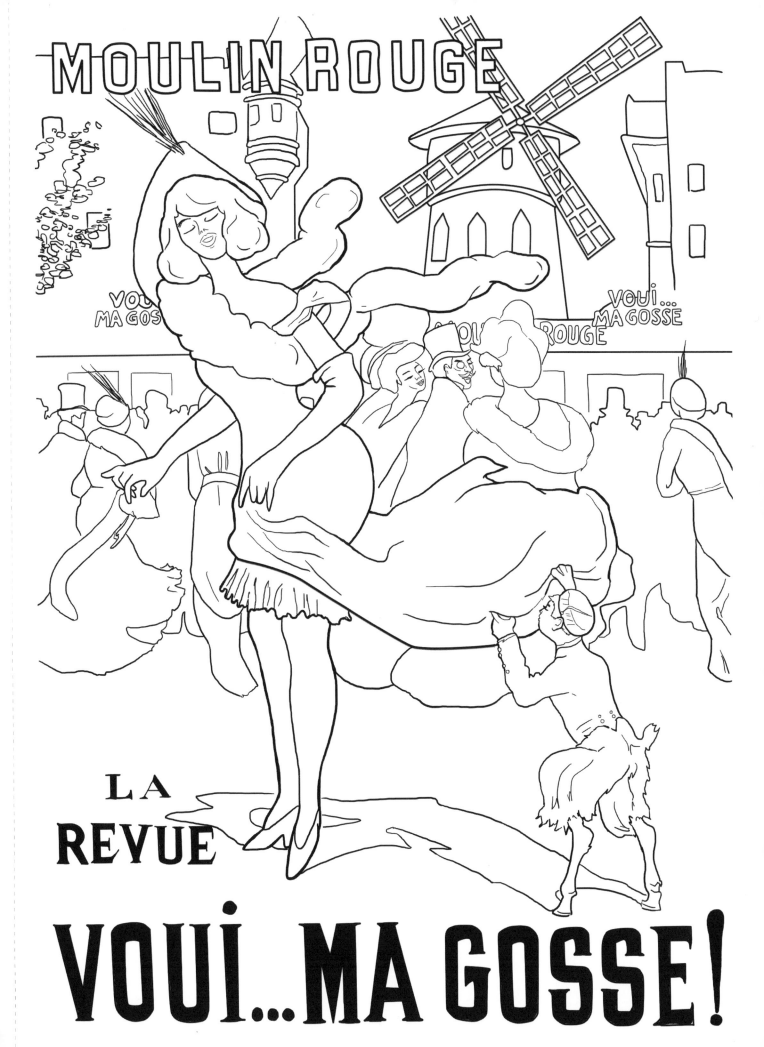

Voui… Ma gosse!
c. 1913
Rouvray & Lemarchand
Audiences were known to chant, "Yes! Yes! Yes!," after watching a Moulin Rouge show—a display of their satisfaction at the performances.

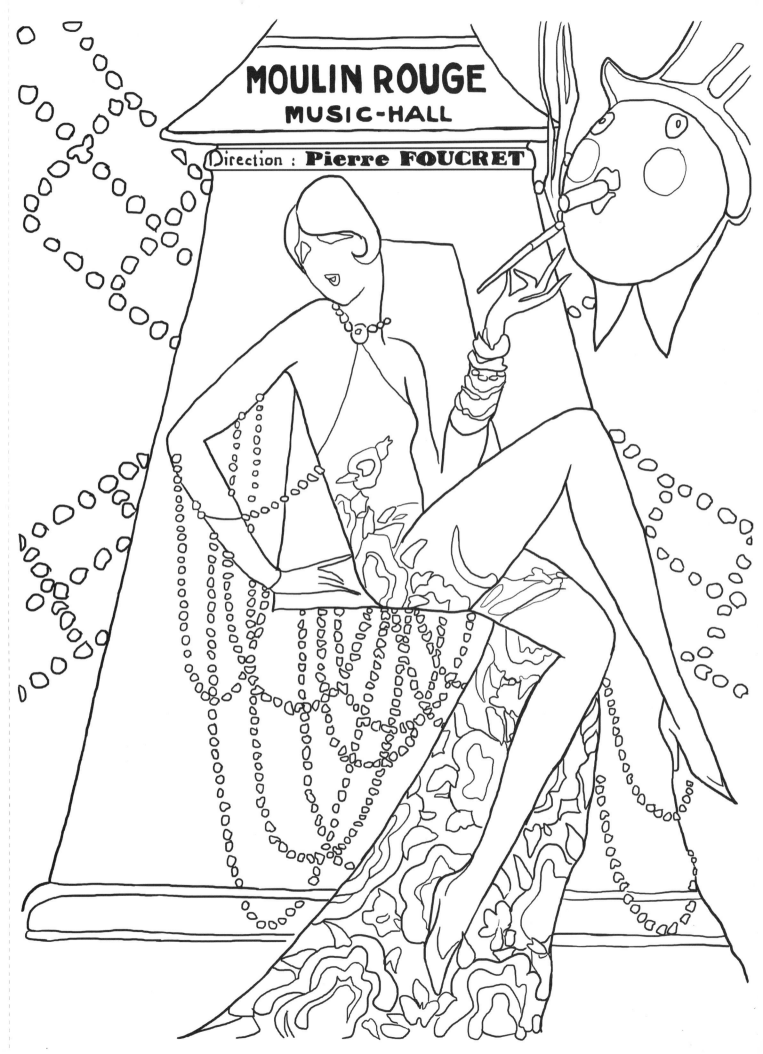

Ça, c'est Paris !
c. 1920s
Charles Gesmar
In the City of Light, spectators rushed to the Moulin Rouge to experience the show, *Ça, c'est Paris!*, which was skillfully driven by Mistinguett, the artistic director of the Moulin Rouge at the time.

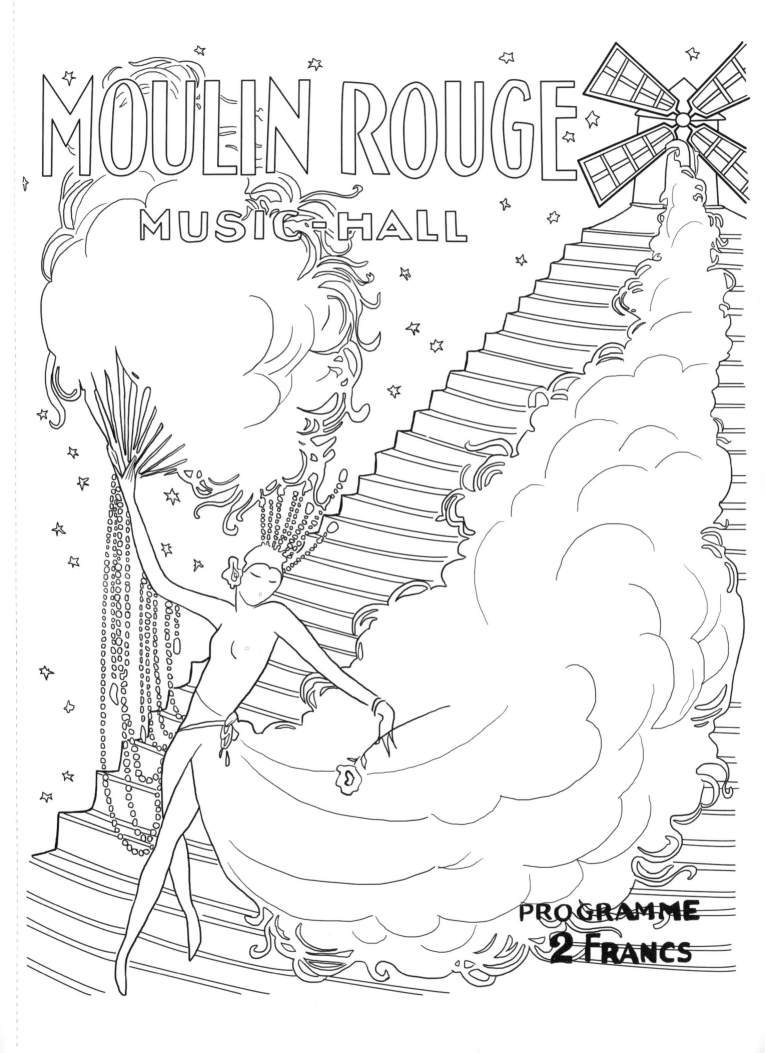

Mieux que nue
c. 1920s
Charles Gesmar
On the stage of the Moulin Rouge, thousands of outfits have been paraded featuring everything from diamante, ostrich feathers and fur to flannel, leather, pearls, and silk.

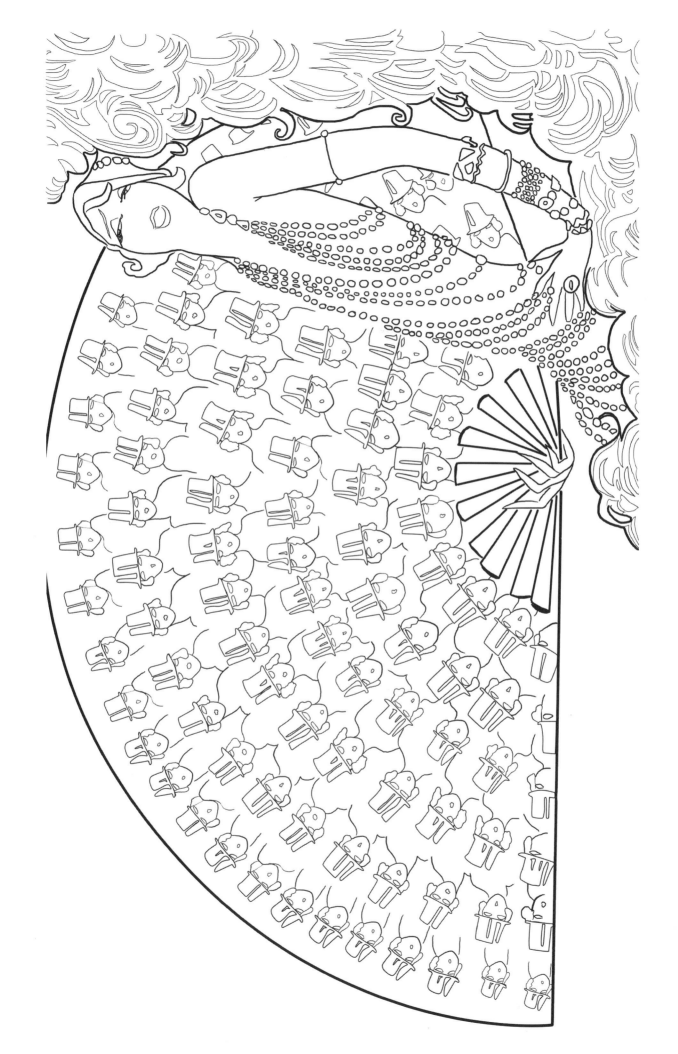

Ça, c'est Paris !
c. 1920s
Charles Gesmar
This extravagant sketch from Gesmar, picturing Gentlemen wearing top hats, gave birth to one of Mistinguett's favorite costumes.

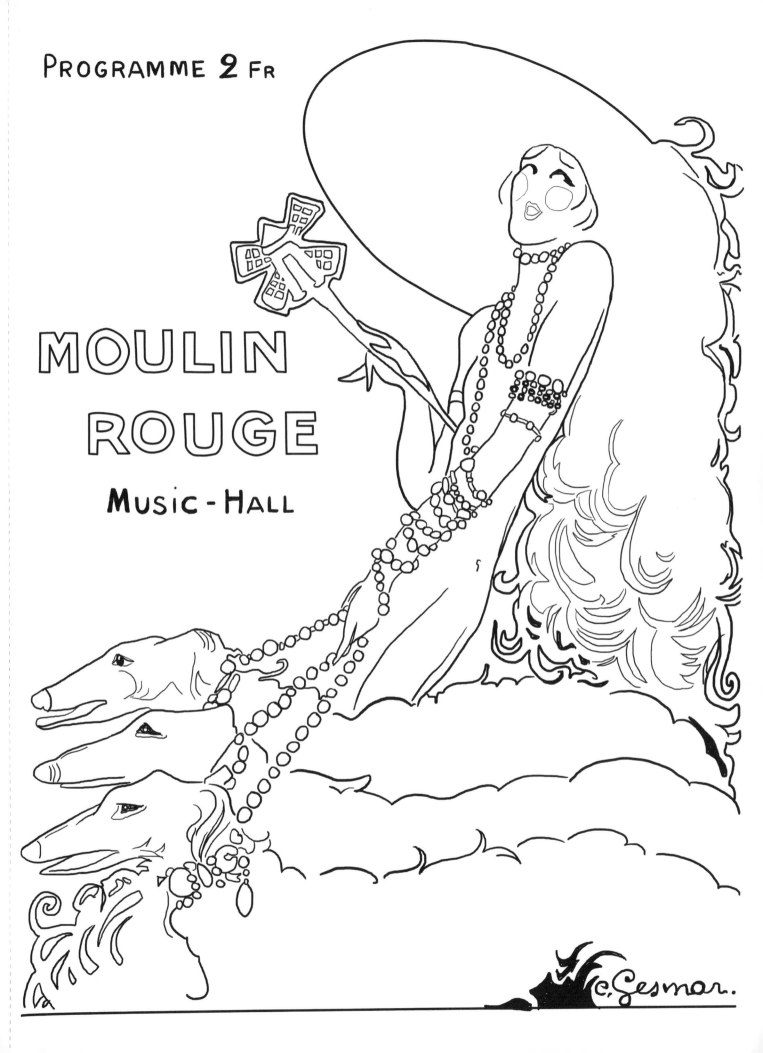

Paris qui tourne
c. 1920s
Charles Gesmar
The Roaring Twenties was a fascinating period that emphasizes the social, artistic,
and cultural dynamism of the Moulin Rouge.

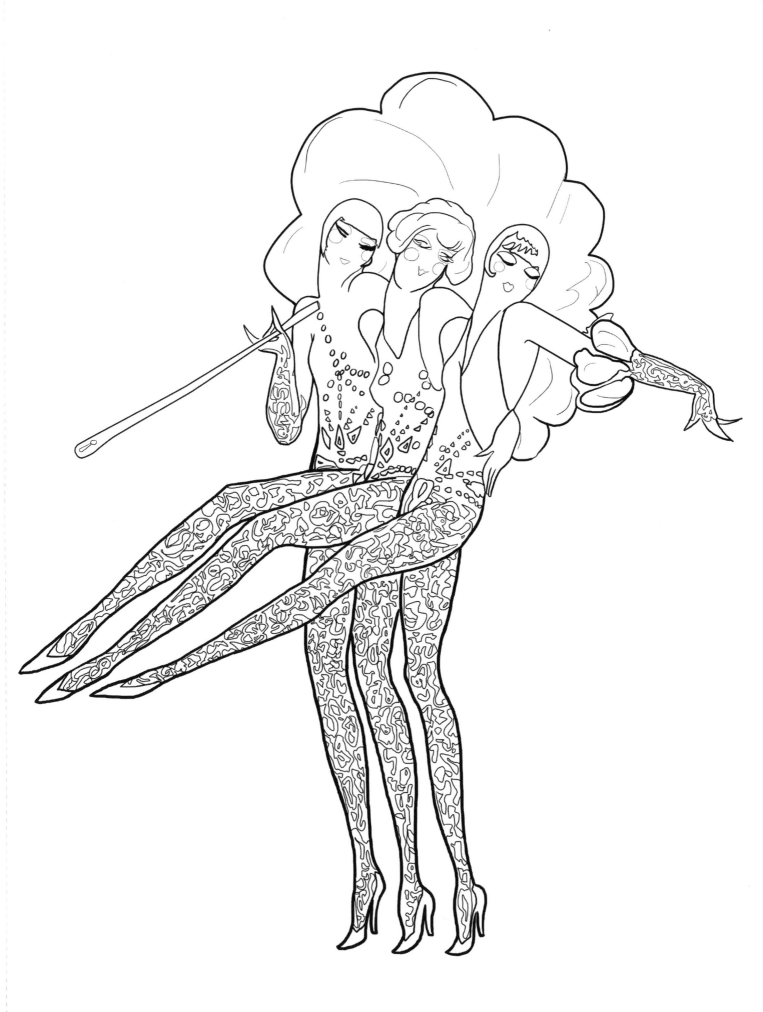

Costume sketch, "Triplettes"
c. 1920s
Charles Gesmar
Three dancers perform a big show every night in a flight of petticoats and lace that gradually builds to an unbelievable French Cancan climax. This is the timeless and heady French Cancan.

Paris aux Etoiles
c. 1920s
Charles Gesmar
Diamonds, emeralds, and sapphires blend their multicolored reflections with those of the stars. Lighting effects then turn the reality into a fantasy. It's just another night under the stars with the Moulin Rouge!

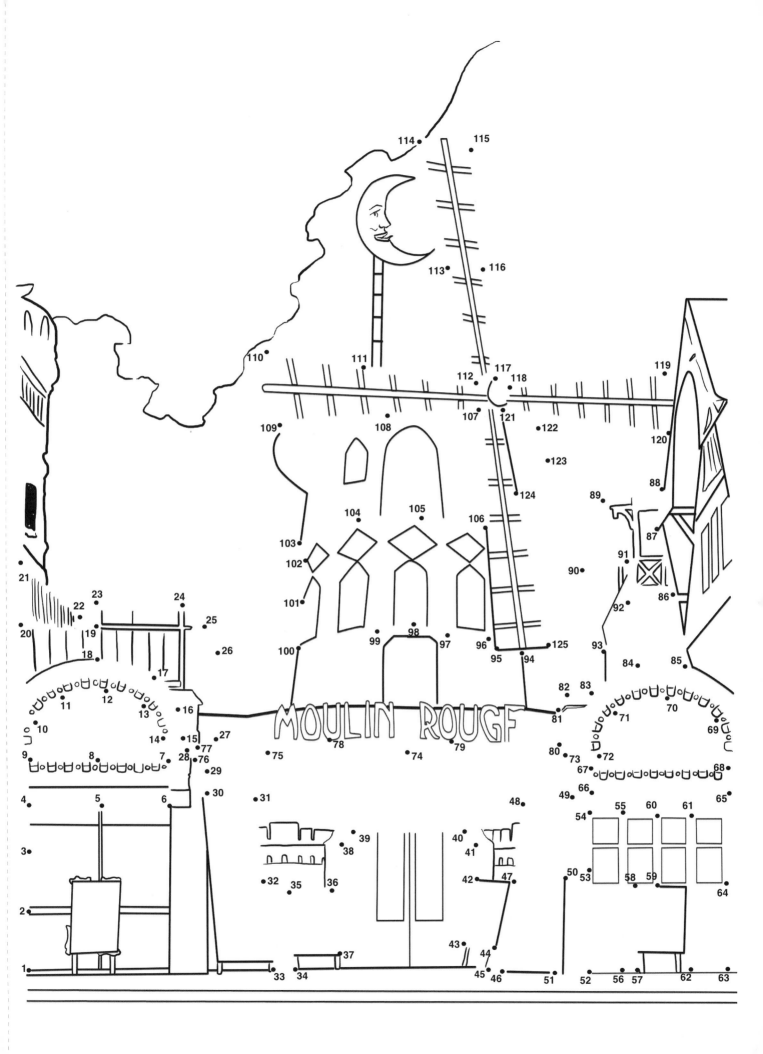

MOULIN ROUGE

Moulin Rouge postcard
c. 1900
Villefroy
Trends do not last, but the Moulin Rouge endures. The emblematic façade continues to be a dream day and night where its wings awaken to illuminate the whole of Montmartre.

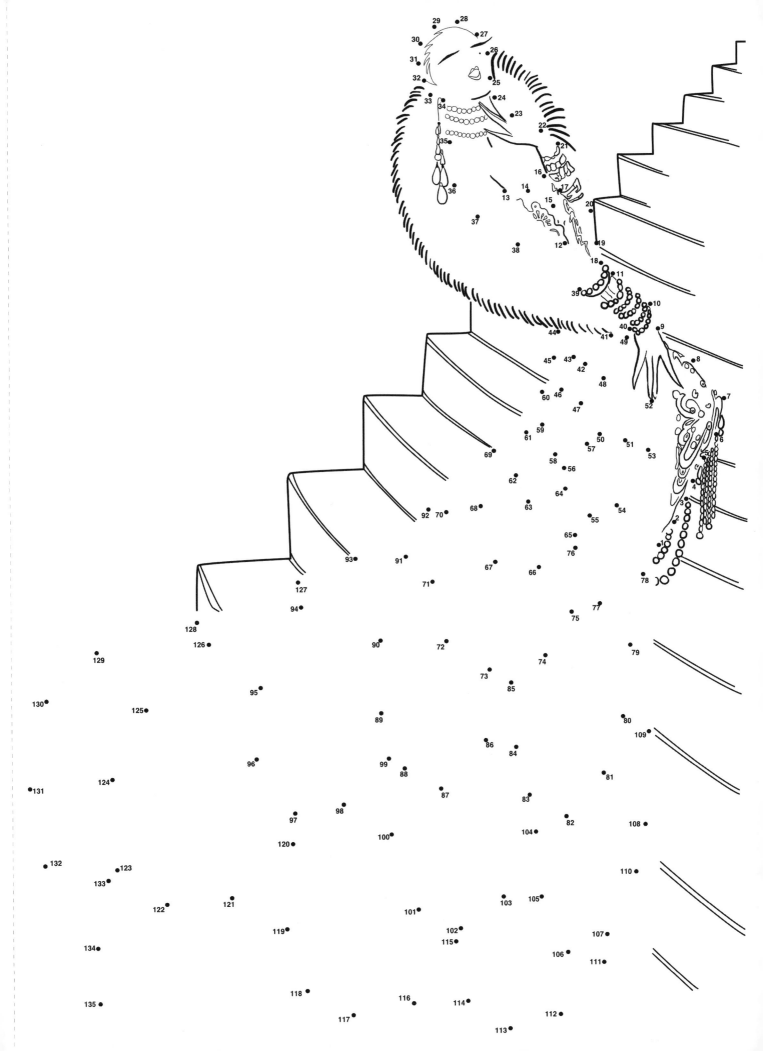

Costume sketch
c. 1920s
Charles Gesmar
The couture workshops of the Moulin Rouge illustrate the incomparable know-how of Parisian handcrafts.

Costume sketch
c. 1920s
Charles Gesmar
Gesmar liked to have fun by drawing his models—the famous dancers of the Moulin Rouge—and dressing them in sublime outfits, the most inventive and creative possible.

Costume sketch
c. 1920s
Charles Gesmar
Gesmar, as a complete admirer of Paris and the Moulin Rouge, succeeded in transferring the flavors and trends of the city into his own art. The Art Deco style that is adapted in the costume here takes its name from the International Exhibition of Modern Decorative and Industrial Arts, which was held in Paris in 1925.

Costume sketch
c. 1920s
Charles Gesmar
Here is an Art Deco-style inspiration for a Moulin Rouge revue show. The shapes are sleek and highly structured, lines are geometric, and the object of adornment is treated like sculpture.

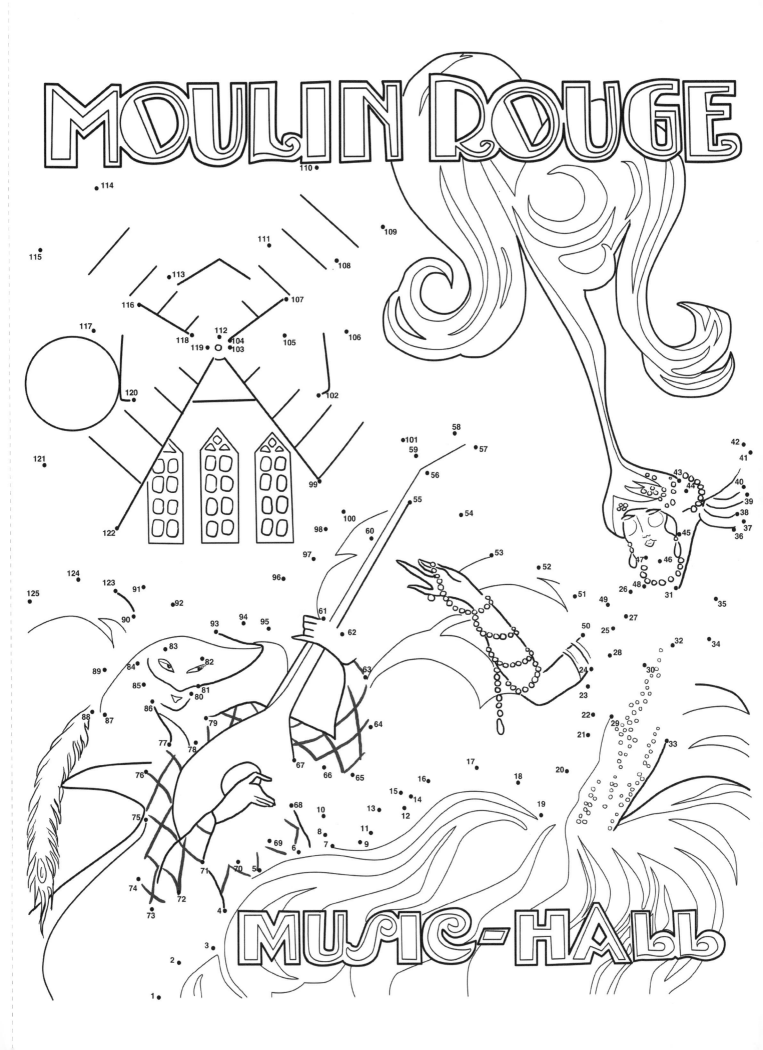

Music hall
c. 1924
Edouard Halouze
Mistinguett, as the creative director of the Moulin Rouge, revolutionized the Parisian dancing scene by introducing the from-now-on famous Music hall entertainment on stage. Hence, a legend was born!

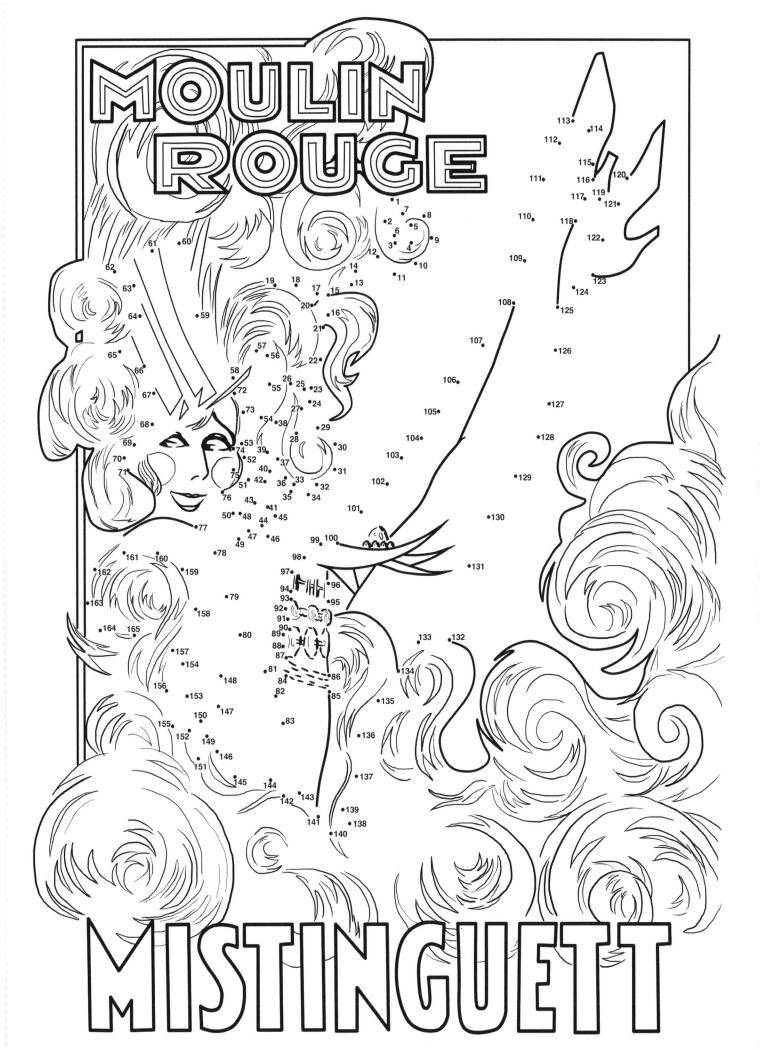

Mistinguett

c. 1928

Rougemont

The Moulin Rouge gives birth to very popular dancers who have become some of the greatest Music hall characters; one of them is the splendid Mistinguett! In the feathers and sequins universe, Mistinguett has become the most creative and iconic Music hall showgirl ever!

PARIS QUI TOURNE

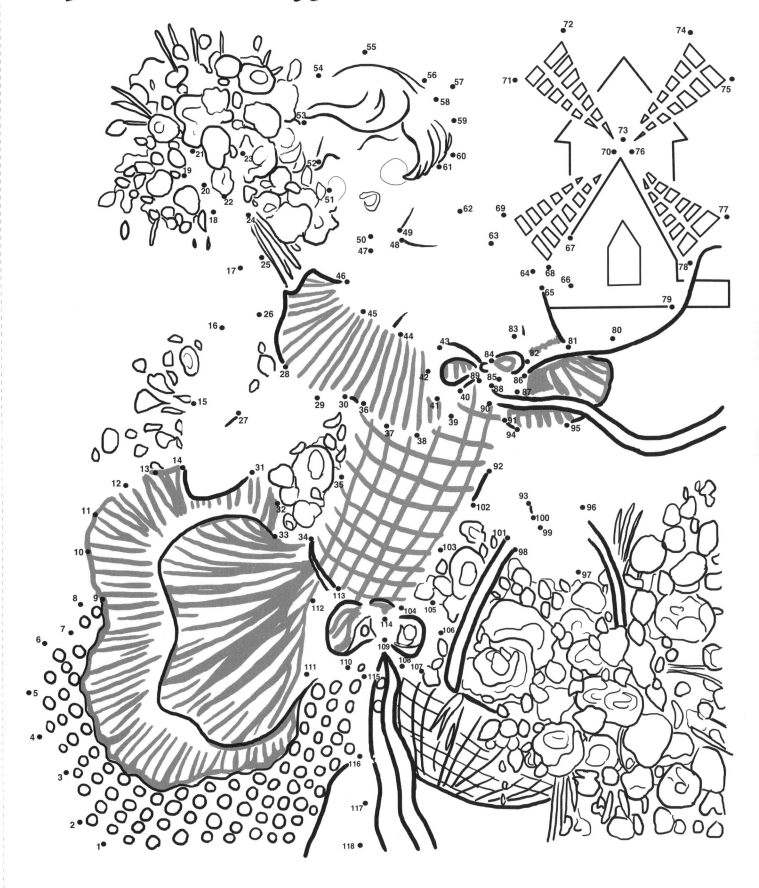

Paris qui tourne

c. 1929

Zig

Spin and spin again! Enchanting moments of celebration, joy, carelessness, romance, and gentleness have been lived and shared on the Moulin Rouge stage since 1889.

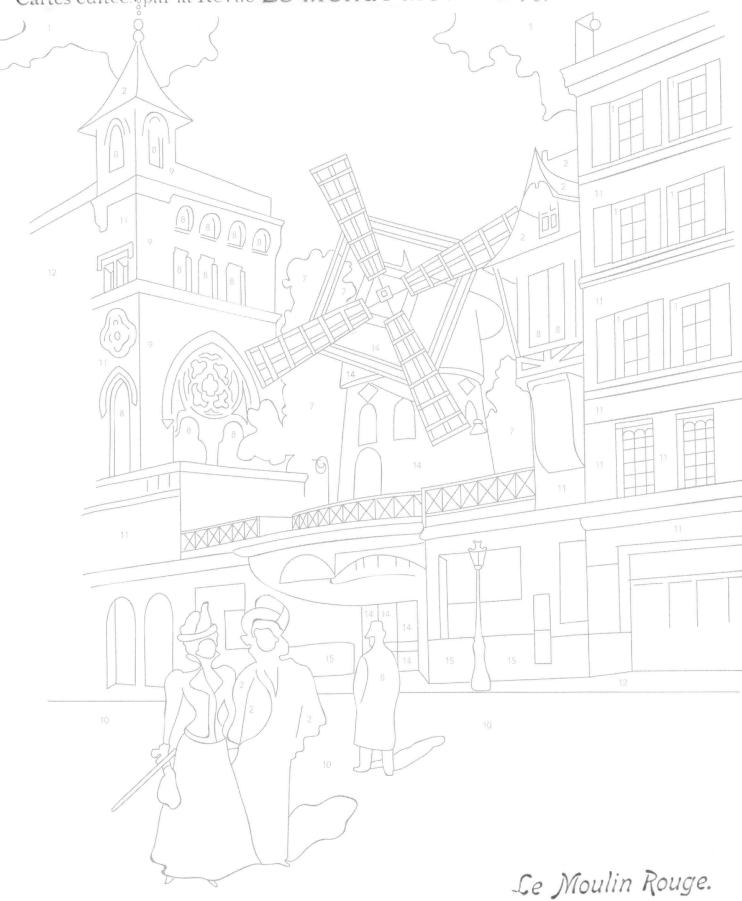

Le Moulin Rouge.

Moulin Rouge postcard
c. 1905
Unknown
"The Moulin Rouge will be red or nothing at all! The distinctive red color of the mill wakes up
every day the sleeping Montmartre."

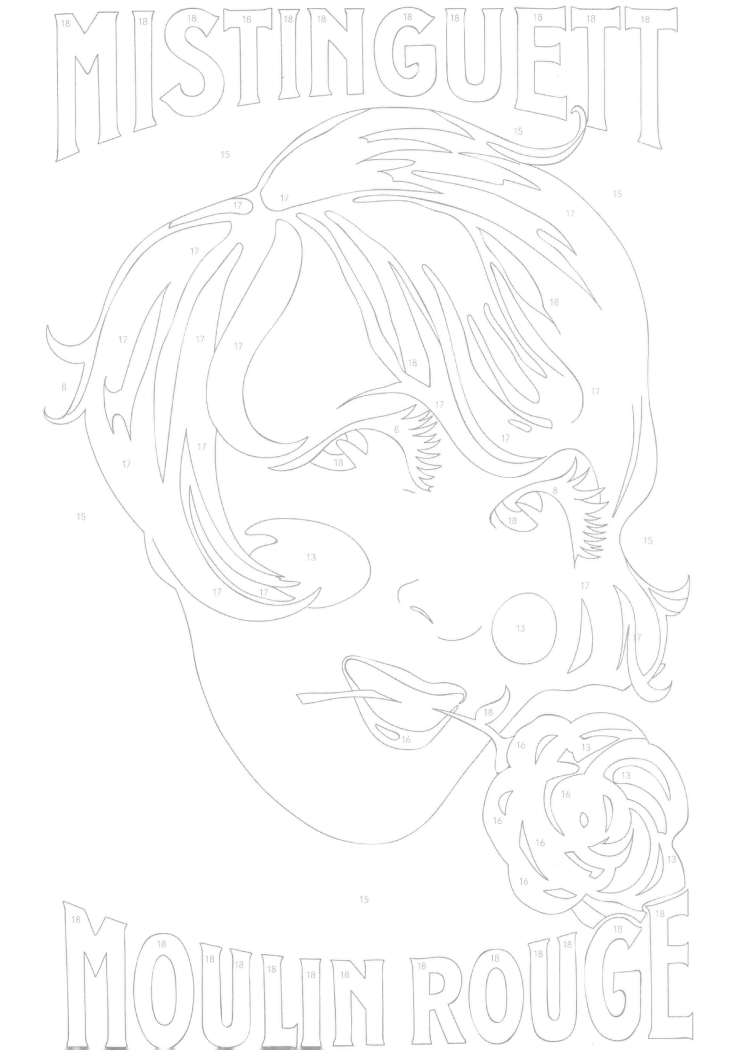

Mistinguett

c. 1926

Charles Gesmar

Mistinguett still represents a fantastic muse for the Moulin Rouge and definitively shaped the Parisian venue's history. She was cheerful, forthright, and cheeky, with sparkling wit and an unrivalled sense of repartee. She loved to laugh with her audience, winning them over by mingling rowdily with them. The stage was her world, her home and her reason for living.

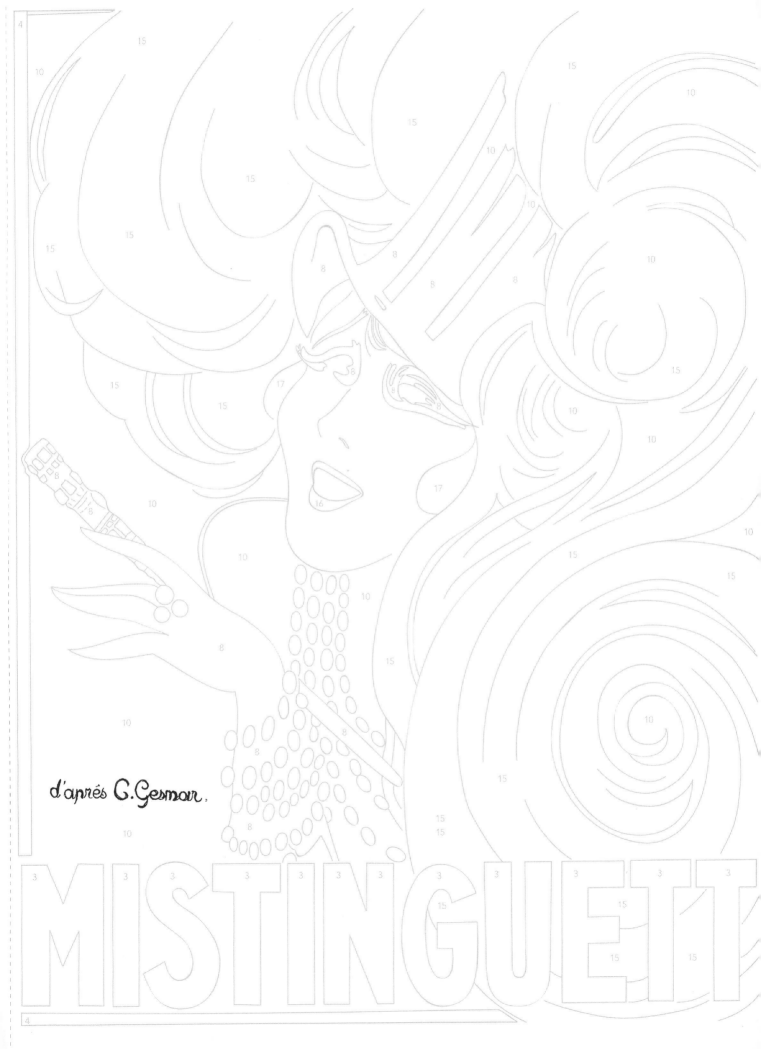

d'après C. Gesmar.

MISTINGUETT

Mistinguett

c. 1928

Charles Gesmar

Mistinguett was a leading figure of the Roaring Twenties. The Queen of the Music Hall was an exceptional and modern woman, as well as a theatrical personality admired by the Paris smart set. She was not particularly pretty or very talented from an artistic point of view, but she definitely set out to be original and eccentric, building herself a style all of her own.

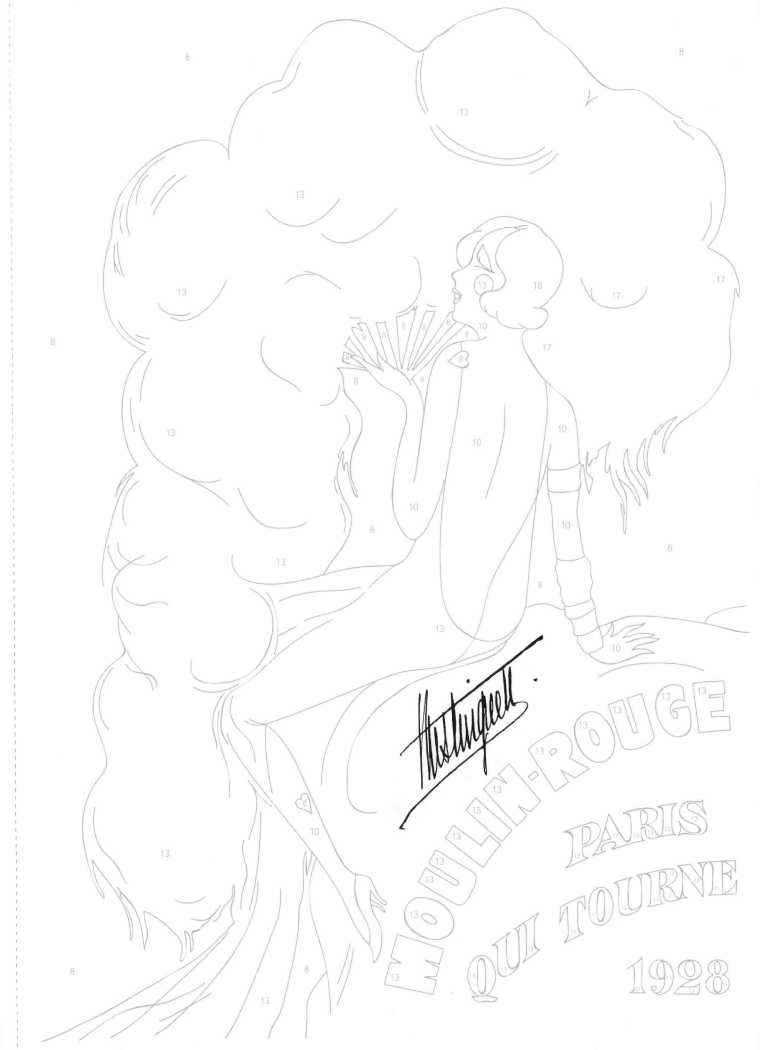

Paris qui tourne

c. 1928

Charles Gesmar

Numerous Music hall celebrities and artists performed on the emblematic stage of the Moulin Rouge. Mistinguett, sumptuously dressed, was without a doubt one of the most marvelous.

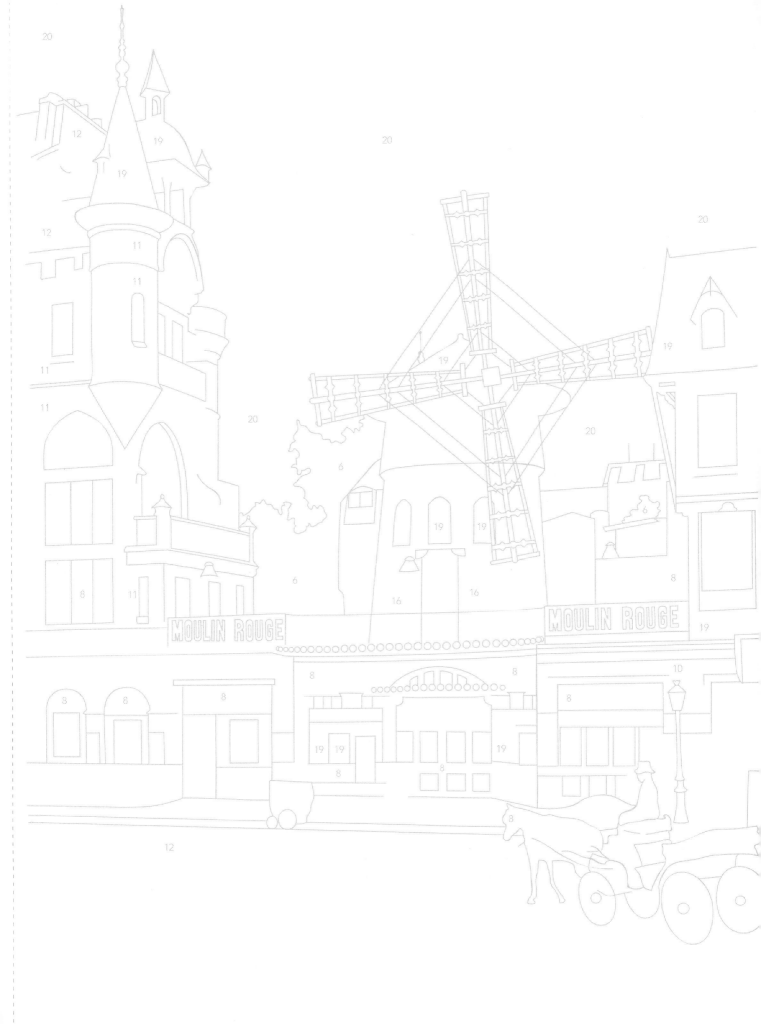

216 PARIS. — Le Moulin Rouge. · LL.

Moulin Rouge postcard
c. 1906
Unknown
In the early 1900s, the Moulin Rouge rapidly became the place to be in Paris. Its characteristic wings
reflect the splendor of the place and became the symbol of a dynamic, playful, and trendy Montmartre,
where everyone came to dance and have fun.

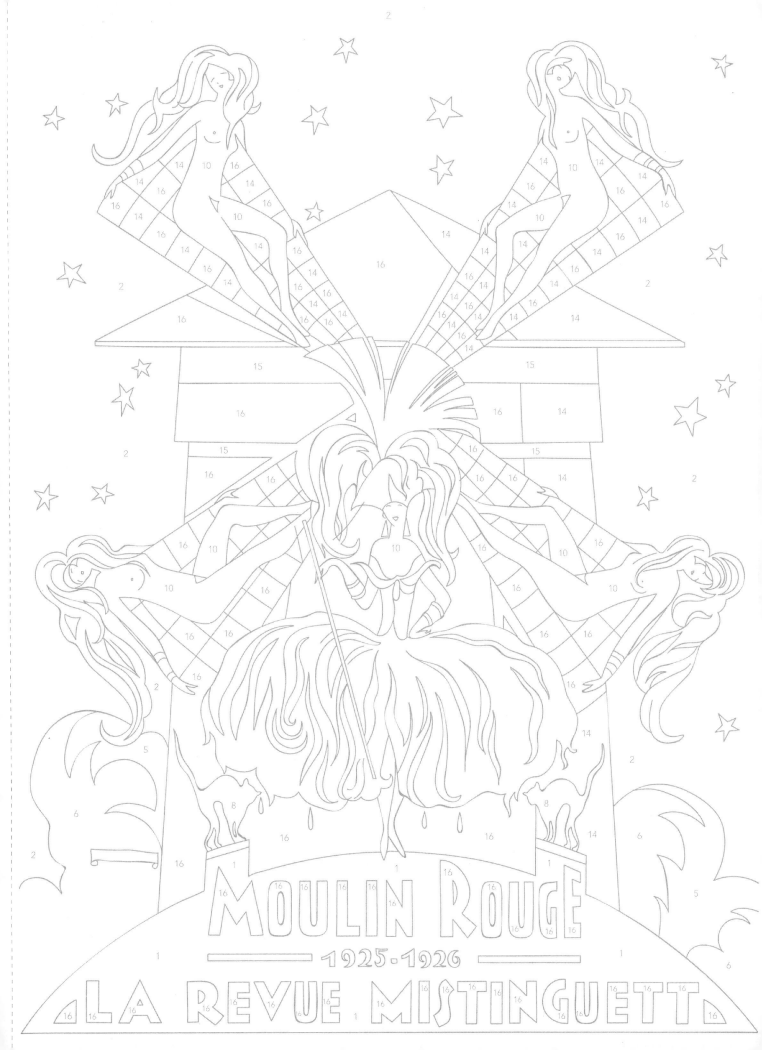

La Revue Mistinguett
c. 1926
Edouard Malouze
The Moulin Rouge is and has always been a venue where diamonds and feathers form part of an incredible journey: highly colorful performances that still dazzle and inspire each spectator every night.